PHOTO,

BOMB,

RED

CHAIR

Previous Books by Barbara F. Lefcowitz

A Risk of Green (Gallimaufry, 1978)
The Wild Piano (Dryad, 1981)
The Queen of Lost Baggage (Washington Writers' Publishing House, 1986)
Shadows & Goatbones (SCOP Publications, 1992)
Red Lies & White Lies (East Coast Books, 1993; fiction)
The Minarets of Vienna (Chestnut Hills Press, 1996)
A Hand of Stars (Dancing Moon Press, 1999)
The Politics of Snow (Dancing Moon Press, 2001)

PHOTO, BOMB, RED CHAIR

POEMS

Barbara F. Lefcowitz

2004 · FITHIAN PRESS, MCKINLEYVILLE, CALIFORNIA

ACKNOWLEDGEMENTS
The author would like to thank the National Enowment for the Arts, the Rockefeller Foundation, and the Maryland Arts Council for their support of her work. Gratitude also to the following journals, in which some of these poems first appeared or will soon appear, a few in slightly different versions.

ADIRONDACK REVIEW: "Lady in Mauve," "Dream-Stone of the Very Old," "Persephone in the Big City," "Rock and Tiger," "Cassandra's Emeralds"
BAYOU: "I Think of Galileo"
BELLEVUE LITERARY REVIEW: "Sentence"
CALIFORNIA QUARTERLY: "Iris"
CENTER: "Leaves of Absence, Leaves of Presence"
CHIRON REVIEW: "Moon Absconditus"
CONCRETE WOLF: "Waiting"
CORTLAND REVIEW: "Spinning"
EKPHRASIS: "Brueghel's *Land of Cockaine*"
FULL CIRCLE: * "Towel, Soap, Cubicles," "My Brain, the Black Thing, my Grandmother's *Tzimmes*," "Dark Olives," "Chains of Light"
LIBERTY HILL POETRY REVIEW: "The Metaphysics of Elevators," "Custodians of the Rain"
LUCID STONE: "Too Late to Reach"
THE MAC GUFFIN: "Omen"
MIDAMERICAN POETRY REVIEW: "Stripes," "Washstand and Pitcher"
NATURAL BRIDGE: "The Mark of Cain"
NEWPORT REVIEW: "Nomadic Flowers"
PERCEPTIONS: "Dust and Stars"
PEREGRINE REVIEW: "Turquoisity"
PHANTASMAGORIA: "Ruins"
PLEIADES: "Marsalforn, Malta," "Adriatic Coves"
POET LORE: "Photo, Bomb, Red Chair"
POETRY REPAIR SHOP: "Harlequins"
PRAIRIE SCHOONER: "Tiger Lilies and Horse Chestnuts"
RED RIVER REVIEW: "Chinese Bookshop, Shanghai,"
ROCKHURST REVIEW: "Ophelia in Middle Age"
SEA CHANGE: "Thermal Pool"
STICKMAN REVIEW: "Badge"
WHITE PELICAN REVIEW: "Arrival of the Oranges"

* "Towel, Soap, Cubicles" has also appeared in Polish in KWARTALNIK ARTYSTYCZNY

Published by Fithian Press
A division of Daniel and Daniel, Publishers, Inc.
Post Office Box 2790
McKinleyville, CA 95519
www.danielpublishing.com

LIBRARY OF CONGRESS CATALOGING-IN-PUBLICATION DATA
Lefcowitz, Barbara F. (Barbara Freedgood), (date)
 Photo, bomb, red chair : new poems / by Barbara F. Lefcowitz.
 p. cm.
 ISBN 1-56474-431-0 (pbk. : alk. paper)
 I. Title.
PS3562.E3738P48 2004
811'.54—dc21
 2003011286

for Nathan, Eli, and Avanika

AVANIKA
On the occasion of her birth, 4/29/03

The better to remember
your exotic & musical name
I break it apart, play each note—
av, a Hebrew late summer month
but close enough to *aviv*, the spring,
for you, an April child, bright foil
to this century's dark & troubled spring;
close also to *avi*, Latin for bird,
may you avidly fly through life,
my spring bird; *an* reminds me
of my grandmother, Anna,
someday I'll show you her picture
like I hope someday you'll show
a granddaughter of your own a picture of me;
ni in the table of elements stands for nickel,
a ductile silvery-white, but hard enough
to avoid being nicked & bent,
my little Nike, my winged victory,
A-va-ni-ka, like your brothers a blend
of East & West, Avanika,
my first & last granddaughter,
welcome to the world & please,
may it be worthy of you.

CONTENTS

PART TWO: Outside the Frame

PART THREE: Between the Lines

PART ONE:

INSIDE THE MARGINS

10 PAST 10

It's 10 past 10 in the evening.
Too late to ski, arrive in Monte Carlo in time
to break the bank, too soon to sleep, barely
inside the borders of politeness to make a
phone call, turn up the volume. In Spain
they'd be drinking sangria, sampling the night's
first tapas; in hospitals, it's time for meds, the
filling in of charts for the night shift.

But here the sky's just the right shade
of blue-violet black to make out
distant city lights before the late news,
its list of crimes and fires, mixed
long range weather forecast.
 Not to be confused
with midnight's ghosts and demons, still
sleeping off yesterday's revels, dream-guests
are adjusting their ties and brooches,
gathering flowers for the hostess. 10 past 10:
a good time to be awake and alive, free
from the need to cross the finish line first,
not yet doomed to stagger breathless
the last few yards before the rope.

RED BALCONIES

The balconies of Apulia recede,
gaps in their balustrades expanding
until they completely replace
the wrought-iron red lace.

Now a lone motorbike breaks
the early morning silence,
crosses the edges of vision.

Nothing has no edges, scientists say,
so this moment cannot be nothing.
Nor can it be solid as iron,
feathery as first intermesh of sun and cloud.

Another moment of space,
of goodbye
to a place we know
we'll never see again.
Yet unlike a moment of time,
it's always possible to find,
no matter how transformed. Perhaps
the balconies will be cobalt-blue
should we happen to see them again,
replaced by barbed-wire lace.
Perhaps they were never red in the first place.

DÉJÀ VU

It must have been discovered
by a solitary traveller
who saw a quicksilver hint,
something vaguely familiar
in the face of a passing stranger

enough to demand a closer look
though no face quite matched
somebody known, likely last met
decades back near a kiosk
that displays the same headlines
the same orangina, Gallois, postcards
of buxom girls sipping absinthe.

Loyal partners, these apparent replications,
more numerous each journey;
affirmations we were here or there
even if nobody witnessed.

And soon the whole world
becomes a source of déjà-vu,
whether or not you have entered
a particular place by foot
or by browsing a picture book.

At which point you can say
you finally own the world inside you,
its cities smaller, yet equally worthy
as those outside, the broken balustrades,
luminous temples you'll never remember,
never see.

OMEN

At the very moment I feast on Ravenna's
blue and gold mosaics or watch a full moon
drape bolts of silk over the stones
of the old city walls of Valletta, Pompeii,

darkness breaks through a slit
deep in the back of my eyes
as if slivers of night
were to enter
through slightly shattered windows
of sunlit rooms:

An omen as yet invisible
to both the opticians and weather seers,
despite their elegant instruments,
prophetic skills, graphs that curve
beyond the range of radar,
maculae on retinal screens—
the first hint that darkness has ventured
beyond its boundaries

sooner or later to assume control
over both inner and outer landscapes,
the black spaces that will replace
the mosaics and moonlit walls—
if not through a blinding of my eyes
while still I can breathe and remember—
then without doubt
when my death shuts their lids forever
leaving Ravenna
to a succession of new generations,
until the sun itself dies, along with each stone,
every moon in the sky.

LEAVES OF ABSENCE, LEAVES OF PRESENCE

Uneven rhythms of glass-
paned and wide open windowframes
across the facades
of factories that shut long ago:
The train must be close to The City.

If I squint I can make out its presence
in a few pointed fingers
that interrupt the smog,
but mostly the skyline's an absence
I see only with memory's eyes.

Now the long tunnel.
And suddenly it's clear
how I welcome the pauses
between a melody's notes
as if they were brief sabbaticals,
at the same time fear that those pauses
will stretch to long leaves of absence,
returning, if at all, to different melodies.

Yet such silences are no more absent
than winter's memory of the leaves
that clung to now bare branches,
leaves of presence, leaf-spaces
that soon will fill again.

—En route Washington, D.C. to New York

DARK OLIVES

It's raining dark olives all over Crete.
My basket of hands can catch but a few.

When the mulberries, too, start to fall from the sky
the net between my fingers sags; a rush of berries

pelts my hair a dark red. Their short tufted skirts
exposed to the rain, pomegranates join

the avalanche of offerings—
almonds, persimmons, lemons heavier than stones—

who could take in such abundance
in a single lifetime, avoid crushing the missed chances
now scattered on the ground—

To console myself I envision
a dark river of fruit

seeds pits crushed-pulp
flowing into the cistern

that has taken root on an Aegean beach
where they'll begin again to bloom

and soon the fish and birds
that fled bittergreen toxic oils

will make their triumphant return,
rise from the sea, glide down the gaunt hills

to join new offerings of olives
and other dark fruits I cannot name.

And the statues will escape the museums
their skin warm and supple

as they pass in marble promenade
each with more stories to tell
than I or anyone could hear in a lifetime.

THE LADY IN MAUVE

A blend of roses and coal-tar, I'm the Lady in Mauve.
Bittersweet as incense, solid as a church,
stubborn as fireweed rising from ashes. True, I love
 to think I'm a nasty bitch
but my heart is a box of candy. The black boots
I wear under my crinoline are just a touch of noir;
like old-time country folk, I never lock the door
 of that birdcage with its maze of hoops
that keeps my ruffles stiff yet swirled
a distance from my body. I swing the door wide
open so a gentleman can reach inside,
 release my captive desires. Still they make
their songs. Like everyone else I was born ten years too early,
ten years too late. In my next life I'll go naked.

THE PERFECT ONE

Born with all the proper social graces
it knows itself so well it never needs
to pose in front of cameras
check its reflections of skin and hair;
even a small hand-held mirror
offends its sense of dignity.

A perfect lady, as they used to say,
the clitoris never steps outside
sans hood, pink suit, matching gloves.
Not that it would touch a thing, imprint
its shape or otherwise disturb a surface,
enter the homes of strangers, expose itself
to potholes, sharp rocks, rough weather.

Yes, it may be a bit of a snob
but never overtly disdains its neighbors,
covets or complains. It lives without attendants
in the house where it was born
and will certainly die, meditates to hushed music
about the privilege of pleasure without any
extra demands on its time, robust health

And like the mystics' third eye
that dreams beneath partly closed lids
it knows to shrug off the frenzied sounds
outside its walls, which not only keep it
apart from the street but always expand
from within, fit like the skin of a planet
that shines with such quiet delight
you'd never suspect it was there.

ADRIATIC COVE

Leaning against
a lopsided pillar-shaped rock
in a cove off Italy's southeastern coast,
I began to think that I could,
make that should, lift it completely
along with the cove's black shells, pebbles, sea-flowers,
slip the whole thing into my pack, add it to the load
I carry wherever I go.

True, the cove would no longer face
Montenegro or Albania, but Maryland's
Eastern Shore, so I could wade only
into a memory of the dark Adriatic
as it flowed into Chesapeake Bay, the Atlantic;
but even as I leaned against that pillar-shaped rock,
its tilt made me recollect the slant of the rain
and that terrible undertow the time I nearly drowned
in the South China Sea, that moment fusing
with a memory of trees tilted almost flat
by the mad Pacific winds
near San Francisco's Cliff House.

That lopsided rock, my self-
christened pillar: it must be a fusion
not only of dust and sand solidified to stone
long before I was born, but yet another meeting
of my flintiest moments, no matter how small or eroded.

So if the purpose of collecting rocks
is to amplify one's cargo of moments
as if they were memories, why let a Samson-like
grandiosity interfere, demanding I hoist the whole pillar
along with the cove, knowing the rock's too massive
by far to take in, doomed to be lost, crush my bones—

I break off a piece, size of a pebble,
slip it inside my pack to join my collection,
my recollection, of memorable rocks.

 —Monopoli, Italy

LISTENING

This wheezing in my chest,
this hush in both ears,
more like unrelenting traffic
than a waterfall,
does not at all resemble
my notion of an inner music.

Nor the halting rush
of an old steam-powered train
inside my gut, followed by a dog
that barks all night inside my heart,
scratching the walls of its four chambers,
gnawing their muscle for openings
through which the dog
can stick its tongue, howl to be fed.

But this time, instead of blood, my body,
for once on my side, will offer a knife
hewn from a rib, topped
with some bone-meal, a touch of salt,
a bit of night music
that entered me by chance
when I breathed a few molecules
from what once was Mozart,
invisible, inaudible to the world outside me.

CHANSON BOHEMIENNE:
1 minute, 32 seconds

An obscure Spanish/Russian/Romanian song
 played with gypsy melancholy lilt,
it lasts just a bit past a minute and a half
 but I listen over and over, convinced
that one particular melody
 makes all the lost moments, all the lost
and distant people of my life and beyond
 converge on the dance floor, a few
stepping forward, then fading, a few named:
 my late great-uncle Moe playing the harmonica
at a family fete, my young grandson Eli, part
 Hindu, part Jew, his dark eyes shining
as he breathes a song from his toy harmonica.
 Greeks pluck strings of ancient lyres, Kyrie Eleison
for the sea wrack cast on a beach, black roses
 bloom in Picardy and on a Galway street
a young girl sings a ballad, tell me who will buy
my violets, fill my tin cup—Ach, Mittel Europa, your
 sentimental brutality
 your tangos of plunder
 your baroque melancholia

My mother would sing Viennese waltzes
 when she bathed me, I hear them along with
prayer bells and Vespas, old laughter
 bouncing down a street, the wind's high notes,
a tap-dance of rain, of a kettle
 when the stick of an ancestor stokes a fire
All the lost moments converge, scatter, rejoin,
 in another direction, all of this happens in unison
as I listen. And when the song moves too quickly,
giving way to a czardas, I reverse the tape,
 listen over and over all night
until the song's so familiar I no longer hear it

THE DREAM PART OF TOWN

If a fisherman's blend of cunning and luck
lets you retrieve from the walls of a house
close, but not quite inside, the dream part of town
a few scraps from a wall's secret groove

and all night you waxed them together, lined them up
in the morning so the sun could seal their edges—
would anyone believe the thing worth protecting
from kidnap by wind or long-handled
brushes of their innermost collectors of trash

would anyone dare touch what you shaped
given the sleazy repute
of the dream part of town,
rumors that gangs of the dead and deranged
flock there whenever they wish, rove
back and forth between waking and sleep
to sate their lust for the living

Yet you extinguish the lamp beside your bed
cross the red line to those hazardous streets
and try, however resigned to another night's
empty hand, to retrieve more scraps, more songs
from forbidden street bands

before they vanish forever
behind *trompe l'oeil* dream-walls that obey
their own tides, their own acoustical laws.

THE PRODIGAL THOUGHTS

• Some of my best thoughts often wander. Nomads, pilgrims, criminals, minstrels, beggars: they take off without warning.

• I think of them roistering in all-night bars, enjoying noisy rounds of billiards and poker, tapping their little feet to loud music.

• And I think of them lost in both strange and familiar neighborhoods. Lost in forests, so absorbed in their own thoughts they stumble on fallen tree limbs, keel over from exhaustion into a clump of underbrush, at times to be awakened by other thoughts: yours, mine, runaway thoughts that have outlived the minds they first entered.

• And sometimes the errant thoughts join, creating new ones with scant family resemblance.

• Some experts suggest I tie bells around their necks or mark them with a branding iron. But should they return, the prodigal thoughts would likely no longer attract my attention.

• That's why I refuse to lock them in my brain-cage, make them sedentary forever. Like any lingering guests, they'd bore me to death and I would do my best to set them loose on purpose.

• Goodbye, adios, ciao, cheers, *scram*...

• Far better to let them go when they wish. Without pleasing or regret, without watching them disappear, outlines becoming so small and indistinct they're soon gone, not once glancing back at me as I rush to greet those new thoughts now knocking my door.

CHINESE BOOKSHOP, *Shanghai*

Seeking shelter from sudden rain
I find myself illiterate
in a bookshop on Fujhou Road,
flip the pages for their pictures alone:
a dragon with sharp wings, a woman
in distress, her hair stiff harplike strings;
fruits & crude replications
of the great T'ang & Sung rockscapes,
paper slick, colors a surprise
of vermilions & mustard greens.

Though I am taller than almost all
the shop's customers, I feel myself
turning smaller & smaller,
a bean, a leaf, a worm that can crawl
through the apple-round earth,
emerge on the reverse of the alphabet,
if only I could find
the right crack between the characters,
those taunting black shapes,
boxed & crossed antennae, locked windows,
pitched roofs on the signs & posters,
row upon row of book covers.

When I turn to the mirror
I see instead of my face
a woman born to eat,
dig roots in a field,
serve her master & sleep
on a bed of stones, her dreams
cut by the sharp wings of dragons
as they pluck the stiff hair
of women in distress.

THE BUCKET

On the stones between two rows
of old brick shanties
far below my hotel window
a man dumps a bucket
of dark amber fluid.
Whoever he is, I'll know
only this moment, this act,
this emptied bucket.
When he opens his door, he shuts me out,
the film of this man and his family
continuing to play like billions of other such films
in billions of theaters for the deaf and blind.

What's it to me that the man
continues, no doubt, to exist?
What's it to him that briefly I've watched him,
whoever I am?
And though I look from a window in Jakarta,
this scene could be happening anywhere
with a slight shift of props—
an alley in Puglia, your backyard, mine.

WAITING

I'm still waiting on the corner
for a bus that might just possibly arrive
after the last scheduled bus of the night

still waiting for Bernard Mandel, the boy
who wore brown corduroy knickers
and stood me up for the 8th grade dance;

for response to my letter, my phone call,
request for more data, my query concerning
the exact trans-rainbow location
of that land I heard of once in a lullaby.

Stars break through midnight dark. Still
I wait for the many apologies I'm owed,
the accolades as well. For return

of all the books I've lent, the favors,
my old skate-key, the Brooklyn Dodgers.
It's getting late and cold, but I wait still

for the next available operator, the beep,
the tone, a voltage converter that works.
The wind tosses leaves at my feet. Yet
I wait still for the cows to come home, for

Lefty, Godot, the Robert E. Lee
and for all those words
dropped and replaced by ellipses

for the end of the war
for next year
for you, whatever your name might be.

THE TRIMMED MOMENT

Everything ended up on the cutting room floor
except the four blue-frosted numerals,
1-9-4-0 embossed on that curve of the cake's surface
visible under its box's lid, the string snapped loose
from the jolt of the braking car
in front of my grandmother's house.

Everything that I touched saw or heard
that particular day of my five-year-old life
clipped forever, to say nothing of all
the events in the Borough of Brooklyn,
the rest of the world.

All sheared with memory's sharp scissors:
my mother holding the cake box, my father
opening the door, the cake's presentation,
presumably to help celebrate the New Decade,
New Year; the greetings, the aunts and uncles,
the cousins, all they said and all we ate,
even the sight of the cake itself, neatly sliced
onto plates; its texture and taste—

All cut away to reveal the trimmed moment
that makes up a memory, its presence
shaped by the contours
of its pared-away absences.
Memory: four blue-frosted numerals
on part of a cake's curved surface.

THE BADGE

In the 50-year-old snapshot
I've almost reached the ladder's top rung,
white strapless bathing cap exposing my ears,
but the Junior Red Cross Lifesaving badge
sewn to my suit where my right thigh
meets my first sprigs of pubic hair, the badge
I was so proud to earn, barely shows.

True, I've yet to save a single life
except my own from time to time,
one hand paddling, the other clasping my waist
just like the Handbook says, hauling myself
onto dry land long enough to slip back into water—
sometimes a clear green where I float freely,
more often muddy black, all my colors merged
when I tried to decide which would best suit
a particular day.

Yet my failure to save lives
might have some merit after all—
had I been there when Robert Schumann
jumped into the freezing Rhine
only to be saved, much to his despair,
by a passerby, I'd have spared him
two years of hell in a madhouse, a death
without music.
Or I could have saved that woman
hauled out of Chesapeake Bay
from a proper death the next day
locked in a hospital bed.

Still I'm proud of that badge.
Regret it doesn't show more distinctly
in the photo, that I have to fill in its shape
in case I should forget all those holds
I once learned, those dives and swift strokes,
head above water so not to lose sight
of what needs to be saved,
in case I should forget as I near
the end of my last crawl
between a pool's ropes.

FLORIDA, 1939

My father was proud of that '39 Dodge,
its skull-shaped green dome, lights that resembled
two bulging eyes near the two steel donuts for spares,
its long running board. Proud how it carried us, two lanes
all the way, the grand tour from Brooklyn to Miami Beach.
 In photo after photo he's polishing its skin, the green
curves of its body. Look how in this one he waves to my
mother and aunt, both wearing coats with huge raccoon collars,
we must still have been north, maybe Baltimore, DC.
Even Uncle Jack shows his face from under his camera's
black hood.
 But where am I?

 They assured me I took that trip the whole time,
my entire five-year-old self. Even quoted some rhymes,
funny words I allegedly said. For proof here's this shot
where I'm building a castle from sand, another near a sign
that says Glass Bottom Boat, 5 cents a ride, a third by the
St. Augustine fort, a wreath of flowers in my hair.

But was that young girl really me, how can I believe
when I don't remember a thing, not even my first
sight of palm trees, the sea, not even the '39 Dodge
except in the album I now hold. Lifting the shots
of that car up to the light, I study its body
for my presence inside, curled in the back seat, asleep
or reading a book, see nothing.

Perhaps just another of memory's tricks.
Was I really back home and they just told me
I was there, told me again and again, like when
they told the same fairy-tales night after night?
But those stories I believed from the start, their
retelling a visit with friends I knew by heart.

If I could open that '39 Dodge, peek inside, touch
the girl's hair or skin—now *that* might convince me
to shout there I was, there I am! X-ray the door's image
to see what's inside, even if the girl reveals no sign
that she knows me and I have trouble believing her hands
are the same hands I now use to cut a hydrangea,
hidden by leaves and thick brush, display it in a glass
so I can see its blue dome, just lightly tinged
with my thumb's knife-drawn blood.

JACKS

Leave her alone:
that young girl you recall playing jacks on a porch.
She's pleased with her mastery of cherry-in-the-basket
and how she can press her six-pointed silvery stars—
some call them jackstones—to a perfect round pancake
the size of her fist, lift it with one move.
Just watch her, how smoothly she retrieves
the scattered jacks, how rarely they slip through
her fingers. But don't rush to tell her a few have escaped,
how sometimes she bounces the small rubber ball
too high. Don't warn her, just leave her alone.

Soon enough despite her best efforts
the ball will roll under the porch
into the latticed dark
from which nothing comes back,
so leave her alone with the clink of her jacks'
six metal points, the jingles they sing
when a light breeze makes them touch—
soon enough they, too, will take off.

Tempting, of course, to try to kidnap that girl,
but why bother? So you can play with her, pretend
you're the same age as she, that you can reshuffle
the past so it fits into a crevice of the present?
Just let her be. She neither knows you nor needs you,
like all older people, you're scary
and she has no wish to visit the future, a place
so beyond the rainbow it has no porches or jacks;
like ogres and goblins it likely just lives in a story.

Let her keep playing
before it becomes cold and dark and she
sets out to find the day's missing jacks,
unaware they're already aligned forever
with the rest of the runaway stars.

PLAYGROUND, EARLY EVENING

- At the playground on East 96th and 5th, three wooden see-saws with identical handles.

- A woman sits alone on the first. One side holds her past, a load growing steadily heavier. It sinks towards the ground as her future rises on the opposite side, now precariously high, too scared to enjoy the skyline's clear view of Central Park West, the Dakotas.

- The past, that fat pig, why doesn't it go on a diet? asks the chorus of nannies. They wonder why the skinny future even tries to ride. Doesn't it know the beast on the opposite side will never relent, lower it closer to the ground so the woman—who resembles myself around 40—can measure the space, always contracting, between flesh and earth?

- Evening light darkens the three wooden see-saws with three identical handles.

- For the child who sits on the second, it's the woman's problem reversed: his brief past tilting high, his prolonged and capacious future weighing him down.

- He looks more amused than upset, but the nannies, unconvinced, try to correct the balance. None can move the fulcrum, push the splintery wood sufficiently hard. The kid laughs.

- I myself mount the third—my grandson declining to ride with me, preferring to chase fireflies in the fading light.

• At once my own past waxes huge, much faster than that of the woman who resembles me at 40. It plunks itself down so the rest of my life's barely visible, refuses to yield one inch of its ample advantage, to feed my poor future a thing—

• Except memories from its vast yet packed repository. The memories, of course, add no flesh to the future.

• But noting my dreamy expression, firmer grasp on the handle as I start slowly to spring both with and counter to gravity, the nannies agree something new must be happening: look how past and future alternate from side to side.

• When it's my future that springs back up, its eyes focus around and beyond the past, lift to the darkening sky, its vast repository of close-in blue fossil stars, young and more distant red stars as well.

THERMAL POOL

So clean so white so blonde and blue
of eye, four elderly ladies
wearing caps with embroidered flowers
lean on the pool's tiled ledge, talking
rapid Hungarian. For all I know,
they're exchanging rumors and pains,
jokes about their long dead menfolk.

> (Is it true that Liszt had so many lovers
> the Pope said basta! in mid-confession?
> Sandor and Imre are going to America,
> have you heard? To become very rich....)

No. I must not move them to another century,
dress them in hoop skirts, set them down
on cobblestones in one of those old engravings:
these pleasant Magyar women
taking the waters this warm afternoon.
Listen how one, plump as a stuffed pepper, cries out
with delight as she mounts the pulsing fountain
in the middle of the pool.

> (How long since anything has entered
> the space between her thighs?)

The others follow, pretend again and again
to be shocked by the water's thumping pulsations,
in and out, in and out, until they're spent from laughter.
I take my turn, pretend to be totally blasé.

Outside the glass wall a young man jogs past
a pony-drawn painted wagon filled with kids—
And I think for the first time in years
of my equestrian days, the cries of delight
when I leaned tight into the saddle's upthrust tip,
broke into a canter, barely holding on,
my feet flying loose from the stirrups.

—Margaret Island, Budapest

CHEAP THRILLS

We vow to say nothing more re 9/11
but my friend can't help pointing out
exactly where they turned into the Portland Jetport
and I can't help gawking at that corner's dingy warehouse,
its ghost of a filling station, scattered bricks.
That's where Atta and the other guy dropped off their rental car.
The Comfort Inn says many ask to stay in their room
Soon a museum, a guided tour in time for the summer season.
Would I take it? Of course. But only to write about...

I think about slumming, those Saturday nights
we white city kids would ride the A train to Harlem
to gawk at the natives and smell their food, enjoy
a brief frisson as if shoplifting lipsticks from Woolworth's
or secretly watching a porno flick.
 The word slum: unstylish now as the practice
of slumming, replaced by more voguish cheap thrills,
like walking through sex shops with half-averted eyes,
curiosity disguised as aplomb, or visiting third world cities,
revulsion cloaked as curiosity, may I take a few photos,
please—for a study of how people live without toilets or soap....

We all do it. Whether we peek through windows
of hospitals' mental wards; watch the dancing fingers
of the deaf; catch up on Chelsea, Diana, and John-John
in the Safeway checkout line; wave a color-crystal wand
for Vibrancy Awareness, read a steamy best-seller, stare
at another atrocity on Fox TV instead of straining the mind's
more intricate muscles.

We all do it. Sometimes from boredom, the wish to believe
we, too, are part of the history of our times; sometimes confusing
cheap thrills with adventure, Mt. Everest's risky demands,
uncertainties of the Amazon. Or with courage, the boldness
of a Galileo, Rosa Parks. We welcome their narcotic effects,
the chance they can help us send death on a detour
towards the doors of our neighbors, most often shrugging off
any motives, hey, everyone's doing it, besides it's fun.

I ask my friend if he knows which Pizza Hut Atta patronized.
Not that I care. Even if I did, isn't Atta safely dead, along with the rest of them?

TOO LATE TO REACH:
in memory of Helen Melnick & Aldeth Spence Christy

As usual I woke up late today
despite my three alarm clocks
& every good intention; too late
to see the rumored shifts of sky
from indigo to violet to crimson;
too late to hear the day's first rush
of spoons & kettle-steam,
counterpoint of sirens & birds.

Too late to reach
those who years ago were more
than kind to me—before I let the rope
go slack, the handle at my end
falling to the street & forgotten
until word of their death
aroused an acute desire
to lift that rope again
though no hand
would grasp its handle
on the other side.

If this surplus of late morning sleep
supplied its own rewards, boxes
brimming with dreams,
release from all day-chores
so not to distract
from magicians of the night
displaying their sleight-of-hand
such sleep might be worthwhile—

but all those lost mornings yield
only a rage to catch up
with what I need to do, especially
the need to waive
what I cannot do at this late hour—
despite my best intentions.

THE DREAM-STONE OF THE VERY OLD

Like the dreamers themselves,
its edges and fissures are so worn by now
the same dream-stone slips through
their loosely woven interludes of sleep
before the very old can grasp it in their palms,
read the traces of its text, the nearly eroded fine print:

> *The War's Long Over*
> *All the Shops have Closed for the Season*
> *There's no Breaking Free from Each Day's Circular Cage*

Still their fingers stubbornly cling
to what's left of their slick
and almost threadbare lifeline,
the very old refusing to die
of a boredom
so boundless and constant
it would long ago have tempted
their own younger selves to let go.

THE FUSED AND THE SEPARATE

No need to know
 at which meridian
 in the longitude of the mind
dusk and dawn hold their secret rendezvous
 exchange reds and blues so they become
 a nearly identical black-tinged blue-violet;
likely not far from the point
 where two breezes harmonize in a choral ode;
 effects shake hands with their causes;
water from the stream at its source
 merges with other streams, soon to join
 the fused waters of Delta, Black Sea.

But none of this assures
 that every before and after
 joins to make something desirable—
I think of a man I saw racing full speed
 down a newly hushed street
 arriving too late for admission
to the locked concert hall. Surely he did not think
 the abandoned street's bicker of cans
 and crushed glass more melodious
than the cadenced laughter and gossip
 of those who moments ago stood in wait
 at the end of the line, then moved
away from the night into the lobby's glow
 on the opposite side of the concert hall's door
 across the music's threshold.

THE GUEST

 Yes, I should have asked for references,
checked its documents more closely
before letting it use my guest room.
 But it had a certain charm and I was lonely,
too distracted to suspect it would stay
more than a day or so and it didn't eat much,
made its own bed, demanded no special favors
like rides to the airport, use of my passwords and PINs.

 So now that sadness has declared itself
a permanent guest, I must study it with care, its sounds,
textures, shapes, though like anything else,
it will keep its deepest secrets hidden.
 Mostly it's the color of merlot,
flexible but tightly woven, like a silk robe
I once bought in Florence. Often accompanied
by Brahms, perhaps Dvorak, it prefers
a minor key, the oboe and viola, no brass.
And the scent always reminiscent,
a blend of camphor and steam, pipe tobacco, the sea.

 It can emerge from its room at any time,
intrude without knocking—when I'm sure
it must be asleep or watching *Casablanca* yet again.
 As well it can float through the air-ducts,
undetected at first, a magenta silk cloud drifting upward,
then all the way down until it touches my head and shoulders,
lands in the hollow to the right of my heart.

I try to use reason: would it not prefer a more elegant room,
with a patio and view? It assures me it's comfortable here,
feels like family. I could of course evict it, toss it to the street.
But assuming it survived the wind and snow, it would
likely be forced to a homeless shelter, quickly trampled,
silk stitches ripped open by the demons of depression
with their meaty prussian-blue hands, kicked around
and left to drown in pools of yellow-green melancholia.
(Or worse, a solid marble emissary of grief
could become my next guest.)
 So I stretch it out gently, shape and fold it:
a shawl that will keep me warm whenever I need it—
or when it decides it needs me. And I sing as if consoling
a child who's stumbled in the dark.

CONEY ISLAND, 10/2001

At Surf Avenue the station at the end of the line
a near perfect match: the aluminum sheathes
that conceal the end-of-season arcades
 and the empty D train
shuffling in a loop on the rust-green El tracks.

Standing watch the old ferris wheel
wearing jaunty coats of paint the parachute drop
gaunt as a skeleton despite its lacquer
 both of them motionless except for a shudder
occasional nod from gusts of wind.

Phantom season's come early this year
 ghosts rising from their lairs
beneath the boardwalk.

On the empty beach my grandson runs in circles
jubilant to discover he's got the power
to make whole flocks of pigeons and gulls
 beat their wings and fly off
just by waving his small arms.

But the rush of music I suddenly hear, an old
carousel barrel-organ, drowns out his exuberant
cries gives way to my own screams of terror
and joy. Hey, I'm riding the cyclone again
tightly clutching my father's hand
as the carnies bellow and the fat lady roars
 what happened to that dark velvet tunnel of love
the jelly-apple cotton-candy shoot-the-shoot
bumper-cars I know
all too well what happened to that not so distant
amputated skyline the Empire State Building miracle
of my childhood now a lonely survivor more poignant

than powerful. the D train again the end of the line
will become the beginning when the train turns around
 but another line black and lacking a foreseeable end
has already begun to slash across the landscape
the jagged split in its fabric wider each moment
memory drifting one way certainty the other way
 leaving behind no familiar train of thought.

THE AUTOMAT & THE NICKEL

I'd dream a torrent of nickels
had rushed into my hands
one to open each glass door
of each room in the mansion
whose walls rose far above my head

I'd twist a door's chrome and porcelain knob
until it sprang open and abracadabra
out would slide a slice of pie
with peaks of meringue high as the Alps
bowl after bowl of creamed spinach

the color of early spring grass
golden fishcakes on thick white plates.
I'd eat just a little, save the rest
for those poor starving children
of China and Greece

who had no nickels at all.
For I was out for more thrilling loot
lamps like Aladdin's
to summon genies
who'd perform my everyday boring chores

a carpet whose woven peacocks had escaped
from *Tales of the Arabian Nights*, a carpet
I could use to reach the rest of the world
if indeed there was any place
beyond the Automat's walls.

Tonight as I watch the late news, no perfumed smoke
fills the faraway Arabian Nights, no peacocks.
Flames burst from carpet-bombs. Tanks
that could fit all the Automats in New York
rumble across the screen.

I search my purse's compartments
until I find a nickel, keep rubbing it in my hands,
as if I could summon Jefferson back, as if
a nickel could still open doors
or anything at all.

FOREVER *VICINO MARE*
for Colin Sargent

You can't stay in Italy forever, can you?
my friend Colin asks in a letter from Maine.

Of course I can, it depends on which Italy...
The honeymoon Italy vanished long ago,
the lagoon where it sank thick with decay
of old promises, shreds of the prosciutto
we believed to be tainted because it failed
to match the familiar, unlike the statues,
cathedrals, great paintings we could match
with their textbook shadows. A blood orange.
A bidet. A red-haired young Dane
who rode a silver bicycle past the Duomo in Florence—
or was it Siena?

The later returns? Yes, I could live forever
in one of those glass gallerias, Milan or Ravenna, forever
in the mansion at Bellagio, trading poems for the
chance music of bells. But my friend the poet-host
died soon afterwards.... Best abandon some Italias,
along with the stench of cats behind the Forum,
bright pink salami, its rivulets of oil stained with smoke
in the second class carriages.

No I *could* in truth stand many days
looking out such train windows. But forever?
Only *vicino mare*, near the sea, as in that
fisherman's ballad from Naples—better yet
not merely near but right inside the sea's heart
off the coast of Apulia, what passes for thought
joined with the surf that never goes home,
never wakes far away from the music of voices
that drift between drawn window-slats, even if
they're only protesting the price of calamari,
lamenting the fall of fresh laundry from a patio's rope—

Because the older I get the more I feel my blood
turn to seawater, the tarantella inside my brain
becoming the slow dance of the tide, turning back
to the sea again and again, the sea off the coast of Naples
you saw from the deck of an aircraft carrier,
and yes, off the coast of your beloved Maine
where it can also stay forever, can it not?

LEAVING ATHENS

Concealed behind veils of gray-brown haze
the Acropolis will not emerge
to let me say goodbye
so I wave from the cab to invisible columns.
Will I ever return?

The driver keens about the choked-up stream
of trucks and buses. Dare I breathe
the dark air that seeps through a window's crack
when a motorcycle spews its wrath and dyes
a line of drying clothes soot-black.
Still I want to turn back.

And the same woman I saw half an hour ago
yawns at the wheel of her Fiat.
Have we made no progress at all?
The same kiosk with the stained Olympic flag
same velveeta-color Grand Hotel Prometheus.

A sudden rain cleanses nothing.
Still I want to turn back.

Yesterday I learned of a special clay vessel,
the *klepsydra:* a water clock to time orations
from the moment a slave unplugged its brass tube,
let the speaker's allotment of water begin
its calibrated flow.

How much water does my own clay vessel
still hold? With no slave to keep time
I cannot know if I have years, months,
perhaps only minutes left
to make the plane that will carry me home
so I can quickly leave it to see
at least part of what I've yet to see,
let alone climb the Acropolis again.

RUINS

a basalt eye
so well carved
if you could fit it in a face
it would describe all your lost days

perhaps a curved handle
to hold whatever you once drank
if you could attach it to its cup

always the ruins
even if so thoroughly dug up and studied
most of their finds are in faraway museums,
always, like memories themselves,
the ruins promise more fragments
if you're not afraid
to uproot a few cracked pedestals
lift the glint of a mosaic
from a floor where you stood
when you were young

but it's the moment itself you want
whether you really danced across that floor
or only imagined you did
based on studies of other ruins
the moment itself—
as much out of reach then as now

or so you reluctantly begin to suspect—
the moment a promise reached so close
to your hand it grazed your palm's lifeline
before suddenly drawn back
for no reason you could grasp

so with hope that conceals what you know
poorly as the figleaf on a broken statue,
you keep trying to reclaim the moment
as if a branch could recall a fallen fruit
by bending low and plucking its stem.

THE PARALLEL EYE

1.
The parallel eye lies
between layers of waking & sleep.

2.
A sliver of a moon
always facing inward
it does not see
so much as shine,
its beam sweeping back & forth
to reveal what it can of the inner landscape.

3.
To reveal but not to record:
that's a task for machines
worked by the fingers
of a parallel hand
embedded in layers closer to waking.

4.
When the hand records
what's been caught
by the eye's beam, it can retrieve
selected artifacts, no longer
in-mates but memories.

5.
Do I fear what that eye reveals?
Everyone does, including beasts of the field,
those very beasts some of us fear.
Yet given a chance, perhaps a tankard of ale,
former in-mates will happily tell
many tales, some wondrous.

6.

Scientists often search for this eye
in all the wrong places—
on the brain's front porch,
in its hall mirror, the small room
reserved for reason, complete with the latest hardware.
Or they wholly deny the eye's presence,
confuse it with a gland, a cyclops, an ornament.

7.

Some would try to enhance the eye's power
with sharpened lenses, elixirs
to force revelation
of wavelengths beyond the human spectrum—
only to discover that the stronger the prescription
the more likely the eye will retreat into blindness.

8.

Do I love this eye?
It depends. Sometimes it keeps me
from sleeping & its images enter, sprawl
over the furniture, make long-distance calls,
disrupt my other eyes' work
& it's so damn capricious!
Yet I cannot see
living without it. That would mean living
in just three dimensions
instead of the four it reveals in memory.

9.
No one has painted The Parallel Eye.
Though some claim its shadow's visible
from distant stars
& it can reveal last summer's baskets of flowers
but no matter how finely dissected & probed
it refuses to reveal its own power's
mysterious grids.

10.
The goddess Indira has gem-like eyes
that shine from her flesh. Peacocks have eyes
on their tails. There are eyes inside our eyes as well.
But each of us has only one Parallel Eye
slim fragment of that primal source
of self-knowing, yet to be seen,
like our bones are slim fragments of stars.

11.
Some never use their Parallel Eye:
donate it to a lighthouse on a barren island
or to an airport's runway
where it will shine iridescent blue-green.

12.

Others would wholly retreat to that eye,
fail to close its lid
before the landscape it reveals
becomes repetitive, too flat & fenced-in,
too protected from the wind
for a shift of vision
so their other eyes never again become
lenses of surprise
as they did when each crystal of snow
sparked a new tint of blue, each string
invited a different knot, each day a new shade of light.

Ah, but treated well,
the parallel eye can dance
with those other two eyes,
make a tritonic particle, triumphant march,
triolet, triple play.

THE CREEK

They dammed it to build more bungalows
but the creek kept flowing
beyond the culvert, far below the broken ground

winding through marsh and silt, meandering
only slightly when its current came upon a rock
too solid for its own rocks to push aside

kept flowing, collecting more cargo
as its volume and velocity increased,
offering free rides not only to cups and shoes
skeins of string that happened to join its current

but sweeping up long buried heads
and fingers of dolls, coins that kids like myself
tossed from an old bridge just to see them
emerge still shining on the other side

nothing could deter the creek's flow
not even memory's wrecking crews,
the creek that still flows inside me

so I've no need to revisit its source
for the place where that old bridge stood
before they built more bungalows

flows inside me along with all my tossed coins
the slippery rock from which I nearly fell
and drowned in the ice-cold water
when my mother rescued me too hastily
from what she believed was a snake

but which likely was only a reed, a piece
of rope, and the creek keeps flowing
from a secret path like the path
that led to it above ground
except its brambles do not cut my legs
and the wild blackberries only look
as sour as they used to taste.

THE LOST

Lost in the Budapest fruit market,
I call upon my troupe of prior lost selves
to guide me, wherever they may
have wandered, Shanghai, Portugal,
South Flatbush, my own backyard.
They obey at once.
 Relieved to meet such a familiar
band of explorers—visible only to me—
I walk with cool certainty past the
mandarin oranges, plums the size of rocks.

By the time I reach the red bouquets
of cherries, I recall my lost selves'
sudden discoveries of shrines and lagoons,
music drifting from a curtain's surf,
 surprises reserved from time to time
for those who swerve, by chance or intent
from roped paths.

Perhaps today I'll just find more apples,
a pyramid of melons, the exit.
 Nothing remarkable
to report to my loyal wanderers
as I become one of them,
my present self soon transformed
to yet another potential guide
for yet another lost path,
location unknown.
So let me salute you, my immortals,
my chorus of lost selves, my maenads,
most loyal followers, despite
a twinge of envy: for like all people
drawn from memory, you never age.

PART TWO:

OUTSIDE THE FRAME

EMPTY CHAIRS

End of season empty chairs
lounge outside the tavernas

such a weight off their cushions
their bamboo, straw, red and yellow striped seats.

Free from serving as beasts of burden
the chairs exchange another summer's haul
of gossip and jokes, compete
for which had the most bizarre items
left behind on their seats—

> *a bikini and bra filled with money*
> *a still-ringing cellphone*
> *can you believe a whole egg, shell uncracked?*
> *and I swear it was a man who sat on top*
> > *that's nothing, this gorgeous dame*
> > *left me her butt as a souvenir*
> *ah, won't last the winter*
> > *wanna bet? I've got these creases to prove it—*
> *more like a sack of bricks*
> > *just look at my cleavage*

Late afternoon. The older chairs lean into naps.
By dusk all the chairs will gaze at the sea
try to deny the inevitable
dark and folded days of hibernation
stacked inside closets, dank storerooms.
A few pray
that maybe next summer
they'll wake in a place
where no one has time to sit down
aside from the chairs themselves.

 —*Chios, Greece*

HOT ROCKS

Good as sex, if not better:
a hot rocks massage at the Wellness Center,
to ignite my currents, at the same time untwist
my body's tight-wired knots; no kinky
kneading and pressing, exposure of covert parts.
 I can come
and go as I please, don't have to look
at the young masseur, his bad skin and his
monster tattoos, praise his techniques, croon
grateful sounds. And my credit card
will quickly take care of his needs.
 Now a blend of aromatic oils, rubbed up
and down my spine, next the strategic laying on
of the rocks, a scalded towel to hold them in place.
I blend into the room's receding walls,
hot and wet, turn into Dali's melting watch,
time winding back to a steamy summer afternoon.

We're making love, I and a man I once knew,
making love on some rocks by a lake, I forget its name,
exact location. He called them the Hot Rocks, though
I recall my own body's heat more than the sun-
enflamed rocks; my delirious fear of discovery—
presumably shared—the whole scene, even the rocks'
empty spaces, becoming more torrid each moment.

Still this is a memory, and like all such,
it not only intrudes but expands, reminds me
of the man's many allusions to those rocks,
as if on that afternoon he had set in his mind
a standard I would never match.
(Took years to recollect some flamboyant
demands of my own).

Enough. I must not let memory
ruin this moment, its fleeting pleasure; all too soon
the young masseur will say time's up, reclaim
his rocks, his smooth basalt rocks, refuse to extend
a souvenir. So I'll sneak a rock between my toes
to fill an empty space in one of those other Hot Rocks,
the big ones by that lake where we made love,
each move another burst of fire
that joined the one before and after,
any semblance of a script, if indeed one existed,
quickly scorched beyond replication.

PERSEPHONE IN THE BIG CITY

"In this column
a hole
can you see Persephone?"
—*George Seferis*

Poor bipolar Persephone.
When she's down in the hole
she keeps looking up

the high buildings sway
though they'll never lean past the angle
set by a pact between gravity and the eye

still she fears they'll crash
bury her alive once again
as soon as she dares to rise from that hole

but when she's up
her head begins to dance a tarantella
on its own, its orbits circling

far beyond her slender neck;
her red-stained throat a hole
still filled with pomegranate seeds.

THE METAPHYSICS OF ELEVATORS

Too caught up in lofty thoughts
about vertical interludes
and the entropy of descent,
even when a lift moves downward
riders cannot look each other in the eye.

A near-sexual coyness, this embarrassed
turning away, upward tilt of the head
towards the flashing digits,
a glance into the mirror, always
dark yellow, should there be one at all.

In the old birdcage elevators
the same awkward rituals of vertical passage.
Nobody sings in counterpoint
with the clank of the cage's door slats.

Few speak. None feels the grandeur
of riding up hills in a red velvet chariot
hoisted by a dozen pallbearers
whose burden sits so high above
it might or might not be alive.

And all wish to flee quickly as possible
lest the box in which they ride
flies through the roof, keeps rising to the stars
or plunges through the earth's inner fires
to emerge wherever the way down
is the way up, in the words of that
ancient mystic Hermes Trismegistus
who would have rubbed all elevator shafts
with his great panacea, crushed essence of emeralds.

MY UMBRELLA

My life's omniscient narrator, it knows
where I need to go next, turns me
swiftly around should I try to shuffle the plot.

One gust of wind and we're off.
My umbrella at the helm
we rise above the setting,
the telling details of street names and trees.
Holding on for dear life, one hand
clutches the shiny black shaft,
one clings to the hem
of my umbrella's red billowing skirt.

And I'm a wingless bird
in a rocket's wake, my double
who flies the arc of my dreams.
No compass to tell where I'm going,
nothing to measure altitude, speed.
We rise higher and higher
to a realm beyond the reach of storms.
And that's when the trouble begins:

All wind power lost, my umbrella hangs in midair,
abruptly dumps me to the ground, drifts
to some other scene. End of story? No,
more likely its denouement,
en route to the climactic chapter
of my life's work-in-progress, title:
The Fortunate Fall. A sequel?
Perhaps. But the umbrella,
wherever it now drifts in search,
by then will have lifted another protagonist,
her plot another trajectory, her story
in some language my eyes
will unlikely be able to read—
if it comes my way at all.

POLIGNANO A MARE, *Italy*

Somebody died this week in Polignano a Mare.
On the piazza behind the limestone church
a little brass band plays a dirge,
grandiose fans of flowers
nod in the wind
to the music's
exuberant melancholy.

Nobody cries. A procession
of black-shawled old women,
men in shabby black suits
slowly approaches the dead person's kin.

When two extravagant chrysanthemums
drop onto the piazza
I come close to retrieving them,
remind myself they're not meant to be mine,
any more than someone else's memories,
the shawls, village grottoes, gargoyles—

Even if the crowd tramples those flowers
to a shimmer of gold and orange shreds,
even if the wind will transport them to me
across the many seas between us.

CHAINS OF LIGHT

It must be a well of stars,
those points of light below
that punctuate the pre-dawn sky,
stars that linger
until the sky shifts from black to deep violet, blue-green.

And the points of light become a chain
rising from the night's bottom layer
to float across its surface
which from 40,000 feet rapidly shifts to a
shimmering quilt, the sea, a field of swayed grass

until the chained points of light
become the lamps of the newly awakened,
each adding a new link to the chain;
another, yet another, tinged and replicating quickly
but not enough to reach the chains
of other villages waking in the distance.

We're now flying over Greece, the captain says.
Why does no chain
curve the neck of a lingering goddess
who refused to abandon her story
when new constellations of myth took over the land;
Persephone, perhaps, rising from the dark
with pomegranates for her mother; Ariadne
tugging the string that links present and past.

Yes, I know. I know they're only village lights
from cubes of white houses
now become visible in the blood-orange sun.
Inside the kitchens women rub black pans
with olive oil, add spice and tomatoes
while their men demand more coffee.

None of those men and women
will ever look down from a plane
at my own distant kitchen lights,
think they're a well of stars, then a chain—

Yet my one-way line of sight
is the only link between us,
a connection loose and quickly dissolving
but more substantial than the broken chain
between the ancient myths
and their successors
between the old gods' torches
and the lights of the people below
as well as my own distant lights.

PHOTO, BOMB, RED CHAIR

It must be a prop
why else would nobody sit
in the red lacquer chair
perfectly centered
between heaped melon-bins, freshly
cut flowers, each melon intact,
the flowers lined up in the sun,
their stalks' shadows crossing
the market's cracked stones, just north
of Netanya, not even a front page photo,
old news, the air stained yellow, perhaps
from burnt oil, perhaps the diffused light
of this mall where I sit; a crow encircles
what seem to be scraps of falafel, or is it
only a ring from the roped-off section for
smokers in the glass and fake marble foodcourt
of the faraway mall where I sit and sip
my iced latte, peer once more at the photo,
page ten of the Post, those white gauzy
ribbons: they must have drifted onto the set,
snarled metal edges of Hebrew letters, a fringe,
still why does nobody sit in the red lacquer chair,
unscarred, so perfectly centered, yes, this time
the bomber entered the market disguised
as a pious old Jew with a shopping bag
which explains the whole scene
in the photo as well the after-images

superimposed as I sip my iced latte
in a faraway glass and fake marble
foodcourt, a fountain splashing
ceramic roses, music erupting
from a black lacquer piano
though nobody sits at the keyboard,
at least ten people dead, scores injured
the melons perfectly intact, flower-shadows
on cracked stones, the bomber disguised
as a pious old Jew, which explains everything
including the empty red lacquer chair
the black lacquer piano that plays on
without a single finger pressing its keys.

THE MARK OF CAIN*

a purple skull-and-bones tattoo,
a third eye, its iris a forked blue flame
 no drivers dare pick up hitchhikers
bearing such signs, fearing
not what such madmen might inflict upon them,
but the reverse: their own impulse
to reach for their rifles despite rumors
of sevenfold vengeance
 •

it's a beard, rabbinical, scraggly, or trimmed,
a shaved head with a single hair—
 warnings enough for witnesses
to quash their suspicions, move swiftly past
without tossing a single stone
 •

women, too, can display the mark
a pierced lip; a wide open valley of cleavage
spiked with gold nails
 but men avert their gaze
or force them to wear thick veils
 •

it's an X disguised as a crucifix
eyebrows curved like McDonald's arches,
a Mohammed Atta brow, Miss America's velcro smile
that conceals her razor-blade teeth
 •

sometimes the mark is more subtle
an extended hand, its glove stained
with bitter oleander juice, toxic residue
of apricot pits; a hole in a sweater, wire-
rimmed specs in the mode of Leopold and Loeb

•

but those who bear
the most subtle marks of all,
invisible to x-rays' most penetrating eyes,
the boy who scans the internet for bomb-kits,
the nurse who deliberately shuffles the pills,
are doomed to be slain upon sight—
 if only someone could distinguish them
from all the other boys and nurses.

* *"Therefore, if anyone kills Cain, sevenfold vengeance shall be taken
 on him." (Genesis 4:14)*

SPECULATIONS

In the distance
the Mephisto Waltz
or maybe Berlioz?

Absurd. No sound at all
could break through that blast

a woman and man joining hands
leaping from the tower together
slowly enough so a camera could catch them
floating midair, but much too fast to survive
if indeed still alive in that photo

They must have been lovers
who'd spent the whole night before
making love; no, likely they were not,
nor man and wife, sister and brother

Partners only for this one defiant dance—
whether they thought it was to or from death,
thought anything at all. Possibly a maid,
her hand still wet from a scrub bucket,
and a CEO who wore a gold watch,
two brokers, bitter rivals; a perfumed
French tourist and a drunk off the street
who happened to wander inside
in search of spare change

Possibly for a millionth of a second
they felt the warmth of each other's palm
the sway of an arm as if one of them
knew all the steps

Most definitely they died
unaware why the tower exploded
and totally oblivious
to American Airlines flight 11
as it took off from Boston
precisely 46 minutes before.

HARLEQUINS

And if dark clouds hover, their tight seams
releasing no rain, if hurricane winds detour,
meteorites fragment to fine silt

And if the crusaders mongols ottomans
huns luftwaffe panzermen cossacks
never arrive and the fever suddenly abates
blisters and subcutaneous wounds
suddenly curing themselves
as if they never existed

Would the disappointment be so keen
we'd split ourselves in half so we're harlequins
of reason and madness, continue to believe
that Armageddon has arrived
see the devil in every streetlight and star
even as we go about our mundane business

Or tired of waiting for danger
would we likewise be harlequins,
this time mirror-image reversed,
ignoring the enticing rumors
of cataclysmic changes
to go about our business
sipping Pernod on the Champs-Elysées, May, 1940,
chanting psalms in a Bialystock synagogue
renting one of death's many anterooms
for an elegant party because, as we all know,
it can't, it absolutely can't happen here.

TOWEL, SOAP, CUBICLES: *A Villanelle in Prose*

1.

En route to the corridor of cubicles, I'm handed a folded white towel by a man with a folded face. And a cake of soap, perfectly square, also white. Enough for a shower or two.

The sign at the entrance promises freedom: from the pains of rheumatic and digestive disorders, respiratory and metabolic conditions, sadness, catarrh, irony, fatigue. As Freud once said about cigars, sometimes a towel's just a towel, soap is soap, a sign a sign.

So don't jump to conclusions. This soap and towel ritual is taking place at the Massage and *Schlammpackung* (Mudbath) Center of a pleasant Mittel-European Spa in 2002. The towel-man's eyes are not blue, his hair not blond and he wears no medals on his uniform.

2.

A cubicle's just a small space defined by partitions. Like a heart. *Cubiculum*, the root, once meant bed chamber. Private. Keep out. VERBOTEN! No trespassing on other people's joys and sorrows, their history. The word *cubiculum* also referred to burial chambers.

Have I mentioned faint sounds of a Strauss waltz? Do you know that Richard Strauss had Nazi sympathies? The uniformed guards at this spa wear embroidered smocks. Quite colorful though somewhat silly, like folk dance performances for the tourists. Yes, the whipped cream is thick and pure, the beer a Baltic amber.

But don't jump to conclusions, tempted as you might be to taunt, "There she goes again" with her addiction to *noir,* to ask me again why I seize upon history's darkest moments, darken them further with my bitter glaze? Stick to happy surfaces, like a travel writer extolling the cafes and street carnivals of Bangladesh off-season.

3.

Soap, of course, is made from fat, whether magenta or yellow, oval or carved to coral roses; fortified with lye or wood ash, pine, rosin, tallow; rendered acidic with citrus pulp; embossed with numbers or portraits or flowers; flavored with honey, almond, anise; scented with lavender, musk...

Let's not confuse cubicle with cubical, the latter referring simply to any object possessing the form of a cube: a solid bounded by six equal squares. Like my white soap. An ice cube, a cube of cheese. The cube root of 64 is 4, and the Cubists stressed geometric form over content, but the name of the island of Cuba has no link whatsoever with anything cubiform. Precision is the enemy of mayhem...

What, after all, is a towel? A piece of cloth in plain, twill or "huck" weave, with a fancy Teutonic pedigree: Old Norse *thvegill;* Old High German *dwahila,* the latter linked with the Anglo-Saxon *thwean,* to wash. Yes, Teutonic. Germanic. But still I caution you not to jump to conclusions.

4.

Perhaps I should not have described the small massage and mudpack rooms as cubicles. Some are quite large, with pictures on the walls of hunting scenes and women dancing in their hoop skirts, fresh roses in their hair.

Ah, soap. *Sapinda Mukorossi! Saponaria!*—the sworn enemy of mudpies and the secret pleasure of smelling one's own sweat, of garlic and sex, everything mottled and tawny. A Teutonic invention, like towels? Probably not.

My mother used to speak of "thirsty towels." The thick expensive kind, for some reason called Turkish Towels, though when I visited that country, all the towels were so skimpy and thin they seemed more suited to the life of a rag. Which might not be such a bad life, after all: rags not only wipe up spills and make things shine, but can serve as clothing if necessary. Skirts, saris, shawls for shaved heads.

5.

En route to the corridor of cubicles I was handed a folded white towel by a man with a folded face. A cake of soap, also white. Enough for a shower or two, depending on one's standards of purity, capacity to tolerate a few stains. The sign indeed promised freedom from rheumatic and sundry other disorders. Freedom achieved not through work but its opposite, a glorious submission to the passivity of the massage table.

With each use a cake of soap becomes smaller until it vanishes. Quickly a clone takes its place, wrapped in bright paper and newly stamped. Other clones await their turn, eager to take up the cause, forever to fight the same futile battle against brindles and imprints, yellow stars, carved names.

A similar process ensures the immortality of towels, a worn towel replaced by one freshly laundered and free from all toxins except for the invisible curse of connotation, a curse it shares with the soap, the cubicle, a few other words.

Because no longer can a towel be just a towel, a shower just a shower, and nothing is pure or disconnected anymore. Even the smoke from Freud's cigar, the cigar may or not be just a cigar. If not quickly extinguished in an ashtray in Vienna, inevitably that smoke mingles with smoke rising from chimneys at the eastern frontiers of Mittel-Europa, from the railroad cars enroute, their airless cubicles filled with valises, moans and cries, broken at times by a Strauss waltz a guard just happens to feel like whistling.

MOON ABSCONDITUS

Tired of trying to shine
through layers of chemical veils
the moon has abandoned Shanghai

its absence confounding astrologers
(who long ago lost their stars)
and shuffling women's monthly cycles
to random hormonal dance.

Fishermen are forced to rely
on the rocking of boats in the river
for any suggestion of tides

bakers have forgotten
how to make mooncakes
for the spring lantern festival

and the night sky's palette
moves from mauve to watermelon pink
to mandarin orange, the sour purple

of dried plums, streaked at times
by neon the color of cheap red jewelry, fake jade.
(Yet the crime rate has fallen dramatically

and no lunatics rave at full moon).
Surely this turn of events demands
a whole new calendar

neither lunar nor solar, based instead
on the spin and toss of newly minted coins,
the rhythmic rise and fall of B-Shares on the Bourse.

CUSTODIANS OF THE RAIN

Agents from the Bureau of Myths
have deported the water nymphs and Sirens
back to the Land of Unreason, deep in the
grooves of the old reptilian brain,
banned the dancing of fertility rites
that demand the spilling of water,
except for a few folklore shows
to appease the nostalgic, students of the quaint
who prefer to deal with elves rather than ozone holes.

Still others find the data, its graphs
and barometric charts, make the planet
seem lonely and cold. Persistently they ask:
who will become the new custodians of the rain?
And when will they arrive, these guardians,
burst full force through stone walls
that ring the sky's many cities of clouds,
when will they arrive to heed our wishes, our pleas?

Those who relied on the rain
to water their gardens so they could tend other tasks
ask the same question as those who trusted the rain,
its most wild torrents, to release their own sorrows,
curb their temptations to indulge in lamentations
so extravagant they'd deplete the currents
between their bones' riverbanks.
Not to mention the lifeguards, baseball players,
all the indoor people who crave a few rain-days.

Soon all the foes of dryness
will form an alliance,
demand to hear new magic stories
to supplant the simple answer
they suspect deep down:
the rain itself, as always,
will be its own custodian.

TURQUOISITY*

So it gives off a green luminosity
tinged with blue,
our turquoise galaxy
well past youth
but far from lapsing
into late life's red frequencies,
prelude to its flames' final sputter—
one more cluster of dead stars,
all the great works and grand notions
of the planet we know best
charred beyond blackness
with the rest of our next of kin
celestial bodies.

Turquoisity:
not such a terrible condition
for middle-age—
the color itself much favored
by tile-glazers, jewelry-makers, the sea;
its yellows submerged, along with all
connotations thereof: cowardice, jaundice,
wind-blown loess that buries vegetation;
its blues restrained, no deep dark laments
of laborers in adolescent fields, no fickle
cerulean skies, none of that self-righteous
icy blue of thin-lipped preachers;
and surely it preserves
much of a pure green's fecundity.

Only one problem: no mirror can reflect
our turquoise galaxy back to us.
To see it one must possess a parallel eye
on some distant star,
part of a universe that will not stop shining
when our own blazes red, then dies.

*Note: In February, 2002, astronomers claimed that our galaxy appears
green rather than giving forth the blue light of newer constellations or the
red of older such.*

CORRECTION

(On March 8, 2002, astronomers rescinded their claim that the universe is turquoise; instead, they apologized, it's beige)

What to do, now that I know
it's beige after all, shade of the 1950's,
neutral chic to match the timbre
of Eisenhower, Vic Damone.

A coalition of Michelangelo and Matisse
could not cover such a colossal space
with colors more pleasing, let alone could I.
Nor can I sustain the turquoise fallacy,
like a fanatic who insists he sees only tatters
and shreds the day following the day
the world was supposed to end.

I could, of course, hope the experts
have it wrong again, deride them
for making the whole universe
monochrome in the first place,
no matter what the solitary color.
Cold comfort: I won't have to see all that beige,
for I'll likely not be positioned to do so,
given the dim chance of transport
to a distant galaxy.

Still I'm disappointed, make that disillusioned.
Wear turquoise glasses? Too easy, too much
like shrugging that the sky's not blue, no face
lives in the rills of the moon, the Red Sea's
not red, neither love nor life lasts forever
and forever itself is a canard—

Better to recall the time
I lifted some turquoise water from the sea:
colorless as sink water once I poured it in a glass.
Still the sea itself retained
its turquoise disguise—until nightfall
turned it first a dour green, then blue-black
with a few rivulets of silvery froth
that vanished to form again somewhere else.

ROCK & TIGER

"The rock wants to be rock forever and the tiger, a tiger...."
—Jorge Luis Borges, in reference to Spinoza's comment
that all things want to preserve their own nature.

If the tiger and rock had their way
both the mandolin and the shelf
on which it lies would still be trees.
The nectarine: a peach refusing to mate with a plum.
And the green bowl that holds it: a double non-being
in a world where blues insist on their blueness forever,
equally stubborn yellows; the bowl a lump of clay,
unshaped and soaked with blood of slain gods
never transformed to hyacinth or laurel.

The bones of the hand writing these words:
still attached to some far-off star,
itself a whirl of dust. This moment
still locked in solidity prior to time.

So what indeed would there be
if the tiger and rock had their way?
Nothing except a rock and a tiger.
A scene that defies the most fanciful eye,
a pre-imaginary world
without motion, without light.

ARRIVAL OF THE ORANGES

Navels protruding from their snow-
sheathed bellies, a few have escaped their box,
its seal loosened by the stormwind, rolled
to the edge of my porch as if in search
of the Florida sun that filled their lobed flesh
with an abundance of fluid.

I rescue them, load them in bowls with the rest
of the refugee-fruit, their globes lighting up
my winter kitchen, a light almost fierce
that makes my eyes hurt. Too much! Too many!
Every year I tell my father
to ship just a few, if any, but he forgets
I'm now alone; the kids in California
have their own oranges.

But I've a hunch this will be my father's last
gift of oranges, and tempted as I am
to give them away to the neighbors, I keep
rearranging, as if setting up a still-life,
hope the cold will keep them from rotting,
keep me from regretting their absence
through all the coming Januarys
when no more oranges arrive.

As if absence could turn into presence
the same way I now see
my ancient father lying in Florida sun
that sheathes his skin a ruddy bronze
as simultaneously I see the snow
so fiercely blown that it curtains, uncurtains, then
abundantly bandages all of my windows.

PEAR CAPRICE

With their curvaceous hourglass figures,
loose nets of small white stars,
rosaceous pedigree and fragrant blossoms,
why are pears so mythologically challenged?

No pear trees in paradise,
no potions or magical pear tonics;
even the Chinese grant their blossoms
only a minor symbolic link
with mutability and mourning.

It must be their skin, often green with envy
of their rubescent cousins, especially apples,
skins blemished and easily bruised,
lacking a peach's downy gold hair,
the luminous patina of a plum.
Or perhaps, like the violins
they vaguely resemble,
pears demand strings that resonate
with the gentle back and forth of a bow,
yet somehow they never evolved
to their highest potential

like the girls who early on flaunt
their breasts and curvaceous figures
but drop out of school, marry too early,
end up as those tough aging waitresses
in roadside diners, the ones who
show up all winter, no nonsense women
who serve well enough
until replaced by sweet young cherries,
sexy little apricots with perfect cleavage
in front and behind, roseate skins, glints of gold.

LIEBESTOD

from a 1932 photograph of Marlene Dietrich

Except for the year,
you could be dead.
Or posing for your death mask,
a blonde if not quite blue angel.

Only that outstretched hand,
wrapped in black lace
that slinks to the crease of your elbow,
slightly hints you might still be alive

in that famous Steichen photo,
your head propped on a chaise,
eyes shut, your upthrust chin
allowing a glimpse of throat
that the black garlands, so copious,
so carefully arrayed, do not conceal
as well as they hide your arms and breasts.
A black shawl, velvet or crepe,
hides the rest of you.

All that calculated darkness: brilliant
as the gold upholstery nails
flowing in a long sinuous scroll
down the frame and arm of the chaise,
nails more alive than the room's flowers
whether damask, laminated, propped in a jar—
and more enticing by far
than the stiffness of your features,
those hairless half moon eyebrows, waxy lips.

Why so much posing, arranging—
is the photo a manifesto of scorn
for the madmen in power,
a scorn to turn so bitter you would dare
sing "Lili Marlene" for the troops
under lamp-posts by the hostile barrack-gates,
never to re-enter your country alive?

A reprise of your best known role,
Lola-Lola, Queen of the Demi-Monde,
the cabaret chanteuse of Berlin
whose cruelty could charm a snake?
Or a parody of the woman you might be
if born French and not German: an odalisque
dreaming that rose-colored chocolates
drop from your boudoir's wallpaper trellis—

So much for politics.
The more I study the photo, the more
I expect you to rise from that chaise,
slowly dance, making such sinuous gestures
the gold nails detach one by one, silk
upholstery flaring loose to join
your serpentine journey
front, back, and all around
the camera's blinking eye.

LIGHT BULB

Resisting jokes about how many…it would take to change one,
I offer this ode to the old-fashioned lightbulb, silvery filaments
clearly visible through a tapered glass skull, a slight
bulge of its neck above the tight metal collar, ridges
that slope to a black band shaped to fit the socket of a lamp
where after some turns and the flick of a switch
 any hand becomes a quasi-god with no need to say
let there be light.
And that little artifice of a sun will keep shining
until that same hand commands the room's return to darkness.

All so simple when you think that something so shaped
could well have become a fruit a bust a tulip bulb
a real skull, the rest of its body flung in a ditch.
 But instead it's a lightbulb, now commonplace,
but not too long ago seemingly magical.

And the apple on my plate was destined to become an apple,
the dim star I see from my window one of many minor stars
rather than a sun;
 the merged egg and sperm, for reasons
wholly mysterious, fated to become me, rather than a fish
or a moon or whoever might have taken flesh
if the runner-up sperm had won the race
—or the race had been scrubbed that particular night—

Destined by vague and hypothetical forces
to become a particular person
born at a particular time and place,
granted a chance to visit this particular planet
for a particular span before turning black
as a spent bulb.
 And I add at this point
just one more unanswerable question:
how many lightbulbs does it take
to kindle a poem from the dark?

WALKER EVANS: THREE PHOTOGRAPHS

Music of the Clotheslines (New York, 1930)

Who will score the music of the clotheslines
 strung from fire-escapes to the railings of tenements
 across the wide streets a rising scale
 of pants and shirts the shorter the sleeves
 the higher the notes
 a monotone of socks strung below
 arpeggios of skirts with ragged seams
 looped above all those bloomers
 flapping in the wind that reveals conceals
 their white cotton secrets
 some coming loose
 and flying away forever
like those old
 city clotheslines themselves
 disappearing allegro con molte
 so whoever wanted to score them
 has nearly lost the chance must travel
 to distant villages seeking the world's
 last musical clotheslines
 as one would seek
the last fire-escapes
 player pianos
 hand-wound gramophones
 wooden clothespins
 the rhythmic billowing of sheets

Wash Stand and Kitchen (Alabama, 1936)

Connoisseur of small shifts—
 how a hollow bowl's curves
 placed on a shelf
 at the precisely correct angle
 can hold light that shines
 despite the absence of windows;
 how the oilcloth stripes
 on the table with bony legs
 can balance the cracks
 of the kitchen's floorboards—

Walker Evans perfected
the aesthetics of emptiness.

So a room in a sharecropper's shack
resembles a Dutch interior, the gleam
of the oil lamp's chipped base
hiding a hole in the tablecloth,
a rag hung from a hook
so shadows of its folds
conceal the stains,
plates caked with dirt shoved to the other
side of the camera, along with spilled grease
and the people who live in Hale County.

We cannot hear the raucous laughter
from burghers swilling beer
in a Steen or de Hooch;
we cannot smell the sour wood
behind the propped broom
in a corner of the shack, all visible
bristles intact, the slant of its shaft
perfectly balanced
by the slats of an empty chair .
likely moved from across the room.
A veneer of camera-light
masks the sadness of the rusted stove
so it seems elegant as the pearl
in the ear of one of Vermeer's sad women,
luminous as the milk that pours still
from a Delft servant's pitcher.

Stripes (Southern California, 1936)

Late summer afternoon
 & only the camera knows
 that shadow-stripes
 from spaces between
 the wooden slats of the boardwalk
 slash three women's white dresses
& that matching stripes cut the sidewalk
 under the women's open-toe sandals;
 cakes in the bakery window
 slant across the billboard's ads
 so dark bands seem to split
 the white bottle of milk
& furrows crease the face of the man
 smoking a billboard-size Lucky Strike.
 At the mock French cafe
 shadows crisscross umbrella stripes
 to form angled grids. Neither
 the women nor the waiter notice;
cast seams across the pin-striped suit
 of a gentleman at the next table
 who's reading the news in slanted light
 as evening approaches: a luminous tiger
 whose stripes only slowly give way
 to the dark bodies of wolves.

BRUEGHEL'S *LAND OF COCKAINE*

As well be red harvest moons
shining above the land of the blind,
gold coins on the floor of the sea,
the roast pig and egg on chicken-legs,
both equipped with carving knives,
who wander begging for mouths
past the three sprawled-out wizards of glut
in Brueghel's *Land of Cockaine.*

Flemish paradise, 16th century,
some scholars claim:
such an abundance of food
it hunts for the hungry rather than rot
and the flowers plant men and women
whose only choice is to bloom

but more likely the canvas reveals
a carnival-theater country of mirrors,
satiety of the senses
posing as wisdom while thoughts
wander begging for minds.

THE ONCE NOMADIC FLOWERS

*"...ainsi des vegetaire: leur immobilite fait leur perfection"**
—Francis Ponge, Faune et flore*

Given their features' near sameness,
their lack of expression & absolute speechlessness,
how can we be sure that a patch of wild flowers,
say these black-eyed susans by the roadside,
was not at one time a nomadic tribe
now settled down, having found at last
a place that fulfilled their needs?

Not moved by force of wind or sea
but moving through their own power,
carrying their roots along with them
like any émigrés, but never
sinking them into the earth
to the point of paralysis
until settling down in this particular plot
for reasons they can never reveal;

hibernating but always reappearing,
the same identical tribe as the season before,
each flower knowing its place and role,
never attacking one another, never turning
green with envy: rather, stems & leaves turning
towards the sun to sustain their inborn
green essence until the preordained
end of season.

 Which brings to mind
utopia, a perfectly calibrated,
predictable community, each member
interchangeable & so complete
to evolve any further
would be absurdly out of date
as human beings
who still plow their fields
with oxen or water-buffaloes, beat
their clothes clean on jagged rocks.

 Thus with vegetation: their immobility creates their perfection

LANDSCAPE WITH CACTUS

One is white and hairy,
the inevitable phallus,
dwarfed by a cluster
of pocked green hands,
three parabolas with bristles,
and the *pièce de résistance:*
a perfect dodecahedron,
the nubs on each of its twelve sides
sprouting a radius of thorns,
thin stars a child might draw:
the congregation of shapes
that co-exist in this rimmed desert city,
so compact it fits in a flower pot on my sill.

The wandering prophets, their caravans and camels?
Particles of sand now, too small for the eye;
likewise mirages of the messiah
who will never arrive
and for whom nobody waits anymore
in their graves near what was once
Jerusalem's Mount of Olives.

The stone tablets, too, have vanished,
along with tossed rocks broken off
from their inscriptions, the tanks,
the bombs, the burning flags, the mobs
that shouted in a medley of tongues
around and within the perimeter,
now crowded with various tribes

of sedentary cactus, sometimes singed
by hot dusty winds that sweep across the sill
where my desert city remains intact
inside its borders, silent except for
the rare sound of an ancient ram's horn
welcoming a numberless new year.

IRIS

Prima Donna Purple Diva
Queen of Rainbows—
with her three triplets
of lubricious tongues
a capella solo high soprano sentry
of the gods the iris reigns over
the garden-bed her own La Scala
Staatsoper Met Caracalla

So beware of planting
more than one iris per plot:
another would be not just
superfluous but certain to try
the Diva's delicate nerves

Risking in turn
deliberate exposure
of her white inner tongues
in mid-aria prior to her
body's grandissimo swoon
which knocks down all the props
making lights blink hysterically
as the audience checks its libretti
to make sure the quasi-death of an iris
is not part of the script, then wavers
between anger & shock

A few brawny men in the back
their arms burly as trees
begin to toss purple things:
eggplants & bruise-colored
beachballs pitchers of grape juice
purple hearts from the last war

At which point the rest of the irises
leap from their plot to take over—
bravissimo! enchante! the audience agrees,
scarcely taking note of the Prima Donna's
limp body, carried offstage on a stretcher,
all her tongues lolling. Will she ever return?

OF DUST & STARS

*"Empty Waterloo Station of everything except six specks of dust,
and it is still far more crowded with dust than space is with stars."*
—Sir James Jeans

How many stars would fit in my house?
 Given the thickness of its dust, far more
 than the Milky Way's 200 billion plus
 to say nothing of other known galaxies
 and those not yet discovered.
 But with such limited space
 they would have to be smaller
 than those gold stars for good penmanship
 in our old notebooks with the black
speckled covers that resembled flat cardboard starscapes
 or small as distant stars appear to the eye,
 nearly invisible despite the sharpest lenses.
 Some might only be shreds from the husks
 of dead stars—kin to the rest
 of my abundant dust, its layers
 at times shaped like the roses
 from whose dirt they long ago evolved
 others in swirls, pointillist umbrellas

and trees as if painted by Seurat—
 in which case it would be cruel
 to brush them off the bookshelves
 and tables, from the cracks
 between piano keys, as dumping
 the ash of the dead to stuff a bunghole
 in a beer cask or drop to the bottom
 of a dustbin.
Ah, look at all those stars,
 how they add
 a certain sparkle
 to my cumuli of dust,
 an intermittent
 but still
 welcome glow.

NIGHT WINDOWS

- Viewed through illuminated night windows, the most ordinary rooms take on a strange allure, part forbidden city, part funhouse, part mindset.

- A red plastic chair in somebody's kitchen becomes a throne. The man I see sprawled on its ruby frame seems asleep, his mouth wide open as the curtains.

- Next to appear, the rump of a bent-over woman wearing pink neon slacks. Surely she's retrieving more than a pin or button from the floor? She must have found a fallen star.

- But will the sleeping man believe her?

- I must walk many blocks before spying another lit window. But there she is! One of Hopper's plump naked blondes, stretching arms and swinging hips as if just risen from bed.

- A waitress working late shift at an all night bar; a nurse; a whore? Before I can decide, she leans from the sill, looks at me looking.

- Each of us dissolves into her shared but separate darkness.

- Past shelves of black windows I make my way home towards a solitary square of light. Its lamp reveals a snake-plant's tall spires. A green-towered city against the wall's whitescape.

- I admire the effect, and from another angle, a piano at whose bench there sits a woman resembling myself.

- Immersed in her music she does not return my wave, yet when I enter she greets me with a prelude I love but always thought much too complex for my own clumsy fingers to play.

NIGHT MUSIC OF THE ACROPOLIS

All night the dogs howl
where Plato and Socrates walked

Leap towards the full moon
they would pull down and smash
on the yellowing marble
if by any chance
the grief-stricken moon
manages to break through
its black veils of haze

Meanwhile they lurk and snarl
behind broken columns, brace themselves
to pounce and tear each other open
should they sniff
a late bone of reason
which the victorious dog
will dash against the stones
until it splinters

Very late at night
disco music from the Plaka
and the roar of miniskirted maenads
racing motor scooters
around the Dionysius Aereopagitica
mutes the howling
until shortly after dawn
both dogs and revellers sleep at last

In the brief silence prior to rush hour
one might imagine faint words
about the wonders of astronomy,
how the human mind replicates
the theater of stars
as it displays its distinctive patterns—
but likely the only sounds
will come from brushes and scrub-buckets
wielded by squat old women
whom Plato and Socrates would have passed
without seeing or hearing.

WOMEN OF THE WATERS

1. Women of the Hamam

The photogravure of the 18th century
women's hamam appeals more to the
nose and tongue than to the eye,
all those sulphurous vapors
rising from the Seraglio's great pool
to mingle with the frangipani, hashish,
rosemary, ripe melons, so a fragrance
heavy as velvet hovers above
women lounging on the marble terrace,
bathing up to their naked bosoms,
some licking sherbet and nibbling sweetmeats
between rounds of hushed laughter,
shared secrets.
What in the world could I ask them—
if they like the way their slaves
deliver fringed and embroidered linens
balanced on their heads; how long
they could prolong their sole permissible
absence from their masters?
How much they envy the rival wives, yet
feel relief that another womb bears
the next child?

Likely I'd succumb
to such long fragrant reveries
I'd be most reluctant to leave,
as after struggling to rise
from a long quilted sleep
at times I say to hell with clocks
and let myself re-enter a dream
to float once more on its watery surface—
only to find that the pool has been drained
and the women fled, knife-edged
news of the day scoring the marble terrace.

2. *Women of the Mikvah*

Just once I'd like to join
the women of the *mikvah*
at their monthly ritual bath,
while they purify their bodies'
open corridors to make sure
that their men, when they enter
once again, will be free from taint
of blood, birth, any secretions
which might conceal nature's
tricky little microbes, cunning
invaders of the flesh that, god forbid,
can render it soft and hairless—

Assuming they do more than chant
and sway, like women at the Wailing Wall,
I'd like to hear what they have to say
about marriage and family, the latest
gossip and news, liturgical issues.
I'd ask if they enjoy their husbands'
arrival inside them, if they've ever dreamt
of turning their men into swine;
worse by far, into women—

Or if they're totally indifferent
to the men's thrusts and cries
like those who lug buckets of scrubwater,
mops to disinfect hospital corridors,
all the time ignoring the groans of patients
whose rooms they pass by
while dutifully performing their daily chores.

3. The Cabana Women

Always in the photos they look jubilant
in their bloomers & black tanksuits:
the women who stripped & dressed
in 5-cents-a-day cabanas, tin cubicles big enough
for a towel & a leaking pipe of a shower
before they got back on the stinking hot subway,
Brighton Beach or Coney Island, ca. 1922.
I can hear their boisterous laughter
as they dip their feet in the surf, pearls of salt
clinging up to their ankles; see them tiptoe
up the beach to their spread-out blankets,
reach into bags that serve as picnic baskets
for bread & boiled eggs, roast chicken legs
that soon become seasoned with sand.

If somehow I could join them briefly
I'd be tempted to ask how they felt about jazz
& fast cars, all-night parties, the booze
from crystal fountains flowing onto patios
& blue-violet lawns, gold tiaras. But aware
they're not leftover revellers from Gatsby,
I'd ask instead their thoughts on America's
future (now that all wars had forever ended);
the Flatiron Building, baked enamel stoves,
faraway voices that spoke through wires.
And I'd try on their rose-tinted glasses,
just to sense how a cabana & a dip in the surf
are enough to make a person laugh.

To watch their wonder, I'd talk of machines
that spin & rinse clothes on demand, jets
that in a handful of hours fly back to the countries
from which their own families fled; moon rockets, TV—
how some might live long enough to see for themselves
such miracles. Perhaps I'd even tell about cell phones,
e-mail, DVD, hoping no one would ask how they work.
But I'd spare them from missiles & nukes, bio-terror—
as much for my sake as theirs: why spoil my view
of their day at the beach?

And they'll wave politely when I return to the present
never suspecting I need them more
than they could possibly ever need me.

4. *The Baden-Baden Ladies*

I'd approach as a swan, skim the lagoon
to a glade between the ginkgoes and the silver
maples, slip into my next disguise: a minor Queen
come to Baden-Baden for the waters
and the music; if recognized, I'd quickly hide
inside a Ming vase, emerge a Lady of the Belle
Epoque, draped in silk, my lips pure gold
as the casino chips. So many admirers! Stendhal,
Turgenev, Berlioz, Chopin…Johannes Brahms
consoling Clara Schumann, can that be the Kaiser—
or is it the King? Of course I'd have to be prudent,
avoid the Russian nouveau-riche, with great aplombe
collect my winnings at baccarat, all my disguises intact
until I choose to reveal I'm a Jew.

5. Women of the Village Pump

Through dust that stings to the marrow,
through cinders from burning trash,
with an infant at each breast, a pin
barely clasping the torn rags she's pulled
around her legs for a skirt,
she hauls a bucket, bears down
on the pump's rusty handle
for some yellow-green water,
a few drops for the basin
outside her hut's cow-dung walls,
a few for the field's parched stalks,
all the while trading news
with the rest of the women, yet another
kid on the way, predictions the drought
will last to the end of their lives,
laughing how it will likely endure
through all their lives thereafter.

I leave behind a few coins,
a box of crayons and my wish
to call the whole scene a ballet,
at the very least an acrobatic tour de force,
try to leave behind my wonder
that we live with similar bodies,
who knows how many similar desires;
same century, same planet.

6. Nu dans le Bain (After a painting by Bonnard)

Floating simultaneously
in quilted windowlight from both
inside and outside, a tableau from
apricot to gold to plum, and in her
long blue-green oval of water

no wonder the young woman
in Bonnard's *Nu dans le Bain,*
a hand loosely curved towards her face,
limbs gently entwined,
appears so enraptured one doubts
she ever thinks of emerging,
if indeed her mind has any sense
of either future or past, the need
to eventually conceal her nakedness,
walk across the cold tiles
to lift a basket filled
with whatever rules, tasks, demands
she must carry the rest of her life—
whether fated to be
the woman with a violin

whose gown lightly furls,
her heart a metronome
as she enters the royal chamber
to perform Debussy, Couperin—
or the servant who must button each pearl
embedded in that gown's chiffon.

Yet the longer I gaze at this painting
in the Musee d'Art Moderne, the more
I think of the yet-to-be-born
inside a double bath of darkness and womb,
how the state of bliss we so lightly assume

must be tinged with fears
of the most primitive sort, given
lack of any sense of future or past,
despite the pleasure of the moment
when a swirl of water meets a curve,
slips between thin creases of skin.

7. Perilous Waters

It's only fair that Clytemnestra
took an ax to Agamemnon
while he bathed with his concubine,
and that Charlotte Corday, armed
with a table knife and a silver ferrule
fit for striking the beast she firmly believed
had smashed the chains of royal propriety,
murdered Marat through the heart
as he read inside his bath.

 Think of all the women
who met disgrace or a watery death, from
Psycho's lady in the shower
all the way back to Susanna
threatened by lecherous elders
while she quietly bathed in her garden;
Ophelia afloat on her death-stream
strewing flowers and songs of madness,
Elaine, the lily maid, gliding down the river
towards Camelot and death
from a shattered heart;
the real-life Virginia Woolf, choosing
to yield to the sea the despair
that broke through to her mind's
highest reaches, stones in her pockets
to ensure she would plumb the depths
rather than risk the surface.

What this all means I'm not sure,
tempted to posit some exotic link
between men's envy of women's
inner capacity to bear water for birth
and lift it out of wells and streams,
but then I think of Esther Williams,
arms aloft in "The Million Dollar Mermaid"
and Fellini's watery heroines; of men's
journeys through menacing rivers,
Robert Schumann's attempt
to drown himself in the Rhine, Paul Celan's
death-plunge into the Seine, the foolish
but all too human Narcissus, reaching
not just for love of his own reflected face,
but the ungraspable phantoms
so seemingly real as they drift
on the surfaces of water, whether pools
lucent as polished mirrors
or puddles in a muddy field.

ARTEMIS EPHESIA

What woman would want so many?
Enviable at first glance, the statues
of the Artemis Ephesia
with their many-clustered breasts
from neck to below the waist:
a breast for each of their many lovers
to fondle and kiss all at once.
But such perpetual bliss
could easily become tiresome,
a burden pressing them onto their beds
or wherever Ephesians make love,
damning them to horizontal lives
that lack contrast, shadows for volume and depth.

What woman would want so many breasts?
Unless compelled to feed litters
the size of a city or sell her milk
for a few coins a krater; and oh how they'd
bounce and drag, weigh her down,
demand constant vigilance for lumps.

Yet the man-scholars have insisted
—perhaps from fear, perhaps envy—
they're not really breasts, marble falsies as it were,
at best an old woman's sagging tits, no nipples,
no milk, more likely just clusters of dates,
cherries, grapes, coconuts,
scrotal sacs, camel bags, even blown-up
leopard spots like those once sported by priests.

And now the latest hypothesis:
they're teeth, really teeth, pendulous bilobate canines
much like the teeth of wild red deer
known for their savage antlers.
Anything to make a woman
cursed with more breasts
than she could ever want or need
into a destroyer of men, with more than one
hand-chiseled vagina dentata. Gentlemen, beware:
best to enter, deposit, swiftly depart, grateful
if you escape before she opens
yet another marble jaw.

CASSANDRA'S EMERALDS

*"In modern times many stones lack the powers formerly
attributed to them."*
 —*Bishop Ruy Lopez, 16th-century chess master*

For a full year she fed herself only the finest of emeralds.
Two beneath each eyelid, to revive
her once perfect vision, a deep green neckstone
to ward off fever.

Another, cold & sweet, under her tongue
to stimulate prophetic powers,
pulverized emerald to divert the nightmares.
A handful, of course, embedded inside
her body's most hidden folds
to honor the sacred link between emerald and Venus.

Yet a green fever burned through her skin & she woke
more myopic than ever,
a haze the shade of unripe fruit
obscuring rims & borders. Monsters from
nightmares already dreamt entered with ease
& every prediction she made turned out false.

Were the stones at fault
or she?

Sapphire induced but a shift
from green haze to blue.
Topaz turned her yellow
& when she swallowed
a cluster of night-shining pearls
they rushed to her head as if stars;
bands of rubies stormed her brow's dome
until she was buried by treasure, scant
consolation for having been born
too late for stones, too early
for whatever collusion
of chemistry & faith will become
the next text of prophetic magic.

OPHELIA IN MIDDLE AGE

No longer willowy
I must do pilates and yoga
so my aging heart will not
send me to that watery grave
I once sought when I was
the very model
of a neuraesthenic young woman
my body prey to onslaughts
of lovesickness fevers
I suffered whenever a man would spurn me
(yes, I made foolish choices, melancholy Danes,
guys who rode motorcycles, I'd cling to
their backs as they promised the stars).

As for all those flowers—
I still garden a bit, but mostly
I study the patterns of pistils and stamens
tongue-shaped petals, precisely imprinted,
each the same yet different, how the branches
of flowering quince flare out like flamenco
dancers' arms, click their silent red-violet gems,
wonder why such artistry in such short-lived things—

But I'm no herbalist: aromatherapy
and other such new age hocus-pocus
leaves me cold and long ago I gave up
feigning madness to attract attention,
other warped versions of love.
I live alone, consult no one but myself.
As for music, yes I still sing, snatches
of old tunes combined with those I create
from harmonies of wind and surf.

Lately I've come across fewer
of those wan young writers of
terrible verse—have they perhaps
all been drugged to contentment—
but when I happen to meet
one who even slightly matches
my youthful self
I tell her to eat an abundance
of ice-cream and cakes, forget anorexia,
forget temptations to dance
naked on a riverbank, forget
the pursuit of passion in the guise
of sex, but to seek out the real thing,

the wonders of cloudshine and rain,
aimless walks along paths
that never saw a primrose,
and not to envy deep down those
who marry doctors, lived in pillared houses.

Of course they scorn my advice,
what do I, a middle-aged woman know.
If they survive a slash of their wrists,
an overdose of pills;
if they survive the desire
to be famous as characters
in a novel or Shakespeare play,
if they survive to middle age—
perhaps they'll understand
though I confess
that when I dispense such advice
I must fight hard against my
wish, that recurrent bitch-voice
that insists I'd give anything to be
wan and willowy again.

I THINK OF GALILEO

Tricked by these strangely warm
December afternoons
the tulip stalks that have begun to bloom

will shrivel and die before the turn of the year,
never suspecting their reckless zeal to thrive
would generate their premature death.

I think of Galileo
and of those ancient Greek cosmologists
whose ideas reached beyond the expectations

of their times, provoking ridicule,
imprisonment, indifference, at best
the platonic comforts of posthumous fame

of ancestors I know will remain
nameless and unlauded, their time on earth
unmarked as their dates of birth and death.

Yet more than the merely unsung
I think of those who cannot fulfill
their wish to sing, who crave to record

the strangeness of clouds' shifting maps
of air sharp with blood and burning sea-grass
but never write a word;

those who would paint but fear
their brushes can never match
the meadows outside their windows

dancers whose solitary tangos
glide across imagined rooms
and all who die before their bodies

from starvation of desires
too wild and mysterious to name.

POETRY OF THE RAIN

If I could type as fast as the rain
now striking the balcony and street
I would compose a new epic at once
longer than the Kalevala and Bhagavad-Gita combined

though poetry of the rain
has no stanzas, linebreaks, words,
only sounds whose flow barely skims our ears
as when we're riding a train where everyone speaks
a language so foreign we can't absorb a syllable
and the rain's staccato beat soon becomes
one note without beginning or end.

So how could I find the *medias res,*
the middle where all epics begin?

I tell myself the rain's
not writing poems at all,
it's reporting news and weather strictly from the rain's
point of view and has a deadline to meet,
hence the rush to imprint the latest story
about heroic cumulus clouds
that defended their contours
until a black iron lid clamped down, crushing
all feathery whiteness—

As if all this had not happened over and over
since the birth of the sky.
As if the next storm will not be much the same,
its arrival certain, if not its particular timing.
As if anyone on earth cared
except a few farmers, who have instruments,
ways more precise than reading slanted
imprints of the sky to cope with uncertainties

What a waste, after all, this frenzy of tapping and striking
when I think of all the world's
untyped, unmeasured, unreleased poems.

MY BRAIN, THE BLACK THING,
MY GRANDMOTHER'S *TZIMMES:*
A Villanelle in Prose, Variant

1.

What a disappointment. In the MRI printout, my brain resembles not a cabbage or whorled cauliflower but a loose conglomeration of lotus leaves, their broad curves slightly serrated, the leaves themselves seemingly afloat in a vacuum.

As if we didn't have enough disasters, the TV reports there's an enormous black thing blooming off the coast of Florida, floating closer to land every moment.

My grandmother made the best *tzimmes* in the world, a blend of potatoes, carrots, yellow onions, prunes, apricots, chunks of meat left to mingle their juices in a large black cauldron for many hours, sometimes days.

2.

The more closely I study the MRI, the more I notice a menagerie, a large dark butterfly or moth, its wings symmetrical, a roundish soft crab, what I take to be the sea-horse, technically known as the hippocampus, any number of snakes, a cluster of dots that resembles a swan.

—It's not a flower, it's a pool of squid, one eyewitness says to the television reporters.

—No. More likely an algal bloom, a gigantic diatom, result of natural pollution, claims another.

—Absurd. Can't you Americans recognize a black hole when you see one? This from a reporter for a Belgian newspaper.

—A black hole, *un trou noir,* that rose to the surface, imploded, and is now exploding in all directions. Look more closely...

My grandmother would set the *tzimmes* cauldron on a low flame. Occasionally she would lift its heavy lid to look more closely, stir the contents with a wooden ladle, add a few spices, make sure the juices were sufficiently mingled. If not, she'd pour in some red wine. Or was it only water? Slivovitz, the potent plum brandy favored by the men of the family?

3.

So it's in the nearly invisible striations of these brain-leaves that all my memories reside. Along with the melded residue of countless dreams, most of the conjugations of the Latin verbs I learned in high school, the sequence of British royalty I once knew cold...

Indeed, my television screen reveals that black rays have begun to shoot out from the thing's circumference. Suddenly this woman in a white dress shouts into a microphone that the sun has at last fallen from the sky into the water off the coast of Florida. The sun that turned black from human pollutants.

—At least we don't have to worry about any more Lucifers, a man says.

—At which point a reporter asks if he means there are no more angels left to fall. But the man has walked off, melded with the ever-swelling crowd of eyewitnesses.

I once tried to make a *tzimmes* but it turned out nothing like my grandmother's. Chunks of charred vegetables and meat, the yellow onions mere black strings, the prunes abandoning their pits, carrots slumped. A *ganze tzimmes,* as my grandmother would have said: a whole *tzimmes,* the term applicable not only to meat and vegetables, but any problem that has grown so large and confusing its elements blend together, making it that much harder to resolve, that much easier to dismiss with a shrug. Kit and kaboodle, ball of wax...

Like Uncle Herman's bad marriage, his nasty kids, his business problems, his gangster friends, Aunt Ida's complaints that he stole all her diamonds, I'm sick and tired of the *ganze tzimmes!* And of Mr. Koch, the landlord. All he does is raise the rent and still you could freeze to death from the heat he gives and the garbage is all over the place and the Super always drinks and everything's broken, the *ganze tzimmes!* I would nod in agreement though I didn't understand why she had to use those Yiddish words.

4.

Damn, if there isn't something round right in the middle of my brain.
Round and dark. Pathologists have ruled out a tumor, so it must be an old-
fashioned phonograph record, in whose grooves are embedded all my old
music. Ah, let me hold the film up to a better light. Now I see it's more like
one of those ancient Chinese bronze mirrors. To this day people hang them
outside to deflect the evil eye. A mirror that deflects rather than reflects! But
what in the world is it deflecting in the middle of my brain? And where's the
evil eye? All I see are two ugly sockets.

I must immediately contact the media. I am sure that the round black
thing off the coast of Florida is the lid of my grandmother's black iron
cauldron. All they have to do is lift off the lid…but what if there's a monster
inside? Would I be liable?

My grandmother I remember as short and plump. Often she would
hum old songs even when she had pins between her lips, pins and needles
for sewing. Though years later I learned that she once had a "nervous
breakdown," my grandmother always seemed jolly to me, even with her
seven children and my sporadically employed grandfather.

5.

I look for her image in my brain. Of course, I find nothing. An invisible
presence in one of those invisible memory grooves.

Yes, several burly men have lifted the black lid. Cautiously they peer
into the cauldron while the whole world watches. A monster? Worse:
nothing at all?

I'm not the least surprised when they announce the presence of a juicy
and aromatic blend of meat, potatoes, carrots, etc.

My grandmother's *tzimmes,* probably the last one she cooked.

—Taste it, taste it, I say to the media. I guess they're afraid to taste it. So
I hop the first flight to Florida, dip in a spoon and taste it myself. Amazing
as ever, not a drop of juice or aroma lost in its long sea journey.

Then I begin to fear that maybe I shouldn't have tasted it after all. I
could get very sick.

Later that night a knock on my motel room door, the appearance of a woman with a gaunt face, her hair concealed under a black kerchief.

—Who are you? she asks.

—Who are you? I never give my name to strangers.

—Not even to your grandmother?

—What kind of joke is this? You don't look a bit like my grandmother.

—Because I'm really your grandmother to the 10th power, ten generations back. But the *tzimmes* recipe was mine. You liked it, I can tell.

—OK, lady, what do you want?

—That's no way to talk to your own DNA.

—Enough. Tell me right now what you want from me. Or scram! (Should I have saved her some of her own *tzimmes?*)

—I want you should take me in just like you took in my *tzimmes*.

—Give you a place to stay? But this is a motel, besides there's hardly room. Just this one narrow bed, stale sheets.

—I don't need much room. No bed. No sheets.

—Then what do you need?

—Just let me slip into one of your memory grooves.

—Come on, that's crazy.

—No way to talk to an ancestor. Without me you wouldn't exist. Your heart, your eyes, your brain… The *ganze tzimmes*.

—The kit and kaboodle, the whole ball of wax, is that what you mean?

—You know what I mean.

I let her in. On the MRI she doesn't show up at all. Invisible in all those folds and swirling Schwann cells, grooves, columns. But that's OK. Nobody will suspect her presence.

Of course, my brain, the *ganze tzimmes*, will someday die, with all that's embedded in its leafy folds and grooves, all my memories, the conjugations of Latin verbs, sequence of British royalty…But at the last moment, I'll release her, my grandmother to the 10th power. Forget her, that is. So she'll be free to go off and cook another *tzimmes* for another descendant whose name of course neither she nor I knows.

PART THREE:

BETWEEN THE LINES

ENCLOSURES

Much as I love the openings
of filigree and cracked glass
enclosures exert a greater appeal,
from cocoons to walled cities, pods,
rinds and paper casings
to the loosely woven coats of salt
that sometimes cling to beach-stones;

supplementary skins
offered by tents and caves,
layers of snow; the word itself—
enclosure: luxurious and pliant,
its rim so easy to expand it can hold
barrels, jars, honeycombs, games—
a tennis court enclosed by white borders,
a chessboard, its margins separating it
from the table on which it's set,
not to forget the planks of time
that frame a soccer match, a play,
a love affair, a span of pain.

I don't know why such shapes appeal
even when city walls become ghetto walls,
parentheses curve around each side of a lifespan,
nor what, if anything, they stand for,
even the allegedly sacred circles
or bracelets of stars,
only that they are, demand no mediation
between what lies inside them,
what must linger outside.

CROSSING THE CONTINENTAL DIVIDE

Gaunt, rough-hewn, looming suddenly
above the road, these mountains stun me,

ominous barriers between myself
and the world beyond, a jagged madness

of limestone and shale, constant, impossible
to cross, more wild than the moose, the
roaming wolves I've been warned

can cross without fear that other barrier,
the invisible line that separates them from me.

Still I refuse to turn back, begin slowly
to discern as I drive further west

a natural geometry
in the upthrusts of rock-sheets
angled perpendicular to the wind;

solitary crags and single-file spruce and pine
rising to make the same clear point

about divisions, barriers, boundaries. So now
I especially look for the orderly pleats in the ice
crevasses that break glacial surfaces, treelines

and occasional strands of green that cut
a tundra's monochrome along with bands of snow
whose taut borders never slacken, overlap, melt.

The first sign in miles: I've just crossed
the Continental Divide, invisible border

between symmetries of river-flow, west
to the Pacific, east to the Arctic and Atlantic.

And I begin to see the point, create a sign
inside my mind that welcomes nature's flair
for distinctions and barricades:

spines between dual ladders of ribs
stripes of light that distinguish dusk from dark

the narrow span of my own life, a boundary
that makes irrelevant the lack of such
between the wolves, the moose, and myself

while it both separates and links
all that has happened before my time,
all that will happen after.

SPINNING

Death-rattle
 of the bedroom fan
 gives way late at night
 to the clank of an old ferris wheel
 that spins me backwards
 but like all remembered scenes
 does not move from its place
 in the brain's more playful terrain
 until I realize I'm not
 in Coney Island anymore, so this
 must be the Prater, people waltzing
 to a zither as Freud takes a
 seat on the wheel, tips
 his hat, disappears
 to ski on a snow-cloud
 along with Mahler and, yes, a third man
not the least bit familiar, who might be an émigré
 from either the future or from Mittel-
 Europa, 1939, but I'm not afraid
 because I've been spun to fine threads
 gold chains strung with blueberries
 currants that resemble red pearls
 Soon
 I'll make my own orbit
 around the Jupiter moons, the first to dip a toe
 into the rumored sea below the ice
 If eventually I must
 wake to the last breath

of that bedroom fan
 I could easily shift
 into a rainbow-spoked compact disk
 spinning its silvery music
 in a circle dance
 that continues to play
never dizzy
 or scratched even if compelled
by mysterious forces
to move
counter-
clockwise.

SENTENCE

a moon approaching fullness
the round black lacuna
that will replace forever
the middle of this page
waxes invisibly each moment

a presence I've suspected
since first awareness
of an uninvited guest
at the door of one eye
perhaps the other

long before I knew
the word thief
or implications of the sentence
they robbed them blind

PHASE TRANSITIONS

I'm solidifying.
My liquid days less fluent each year,
their loosely patterned molecular dance
slowing to a sarabande, a solemn march,
as if the Coldstream Guards were assuming
their designated places
to stand rigidly at attention—
their bodies close to the near-pure order
of an ice block, identical molecules precisely arrayed.

But the approach of such an Ice Age
arouses only mild dread: scrolled
with unique rivulets and luminous threads,
ice has the potential to achieve
the architectural grandeur of glaciers;
sea-ice can leap without warning, and
who can scorn the sonatinas of icicles
played by the wind? Besides, ice melts
easily back to liquid, courtesy fire or sun.

More threatening by far
the pure order of a crystal,
prefiguration of death's austerity,
which at best can revert
to random dispersals of ether,
foreign molecules briefly joining, ascending,
scattering beyond the senses.

MARSALFORN

For out of season people like myself
 wintering sea resorts
 appeal far more
than their hot and raucous counterparts.

Take this town called Marsalforn, north Gozo, Malta:
 The Handicraft Centre is closed
 so no one will tempt me to buy
 a straight-from-the-factory hand-knit sweater
Il Forno, the premier ristorante, is closed, likewise
 The Dive Bar and the Paradise Hotel,
La Gelateria Lungomare with its blue aluminum shutters.
 And nobody's littering
 the small stone beach.

True, nobody speaks my language
 but that's only because nobody's here
except an old man asleep on a bench
 squat women exchanging sea-gossip.
No birds. No fish. The wooden boats
 with the eye of Osiris at their bow
 all stacked for the season—

And the new stone villas, mocha, pale gold
with an amethyst tinge, have shut their own oval eyes,
 for the Calypsos who strutted the esplanade
 in spike heels, cleavage & pudenda exposed,
 have all gone home to Valletta, Manchester, Munich—

Leaving the villas free all winter to dream
 of Phoenician sailors who scaled these sea-cliffs
 bearing timber and Tyrian purple;
free to dream all winter of the stone curtains
 linking balconies that would last forever.

THE LIPSTICK REVELS

Their hour at last.
Cosmetics Department, 2 A.M.
Lipsticks emerge from their tubes,
abandon them randomly on counter tops,
émigrés from sleek gold-embossed
Pluparfait Fauve d'Orsay cylinders
mingling with the masses, slunk like turtles
from Maybelline Ready Wear black plastic shafts.

Off to the mannikins! Whose cold lips
they kiss, leaving streaks
of *Aubergine Sunset* overlaid with
Raspberry Ecstasy, Tangerine Dreams.

Then the real fiesta, the lipsticks
lining up inside escalator grooves
for the long ascent, all the while
their slanted tongues exchanging
the latest gossip: who's on sale, who's
fated to be discontinued; who's a pure
organic blend or just a stick of glycerin,
synthetic wax, titanium oxide, C10-30,
tested on small furry animals.

Upon reaching the loftiest designer salons,
they scribble graffiti on Pashmina shawls,
dab the hems of Armani gowns, white
linen collars of Versace shirts, greet
their fellow-revellers, eyeshadows
spreading their powdery rainbows;
green serpentine bath gels, loose pearls
of wrinkle cream, mascara rods.
All swirl to the music of satin skirts,
silk neckties swaying from racks

until with first light the lipsticks descend,
insert themselves at random
into the abandoned tubes, re-enter cases
just in time for the unsuspecting sales clerks
to serve the day's first customers, none of whom
will ever know if the sleek 100 dollar gold-
embossed tube contains Maybelline Ready Wear—
or if the finest Pluparfait Fauve d'Orsay
fills the dollar-plus-tax black plastic shaft.

SONG ALBUM

1. Song for the Toes

Nobody sings odes for the lowly toes,
usually hidden, huddled in fan-shaped curves
at the body's extreme south.
Two quintets, turned east and west
in perfect symmetry, two small keyboards
with no sound, two families leaning
so if they had hidden eyes, each could not
see the other. An ancient feud?
The godfather big toe slightly separate
from his brood, the better to observe
and protect, be the pig who goes to market
while the faithful wife stays home.

But why five to a foot when their kin, those
upper class digits, the fingers, can just as well teach
the young how to count? And also play piano,
hold a pen or brush, speak in signs, entwine
with the fingers of others...
No doubt because of the body's own caste system:

toes the lowest, rejects forced to live in socks
and shoes, cramped, ringless, forgotten
unless frozen or calloused to the point of pain,
nails unlikely shaped or polished unless exposed.
And if there were only three or four to a foot
we'd be like other creatures, no decimals, no dimes.

Yet toes are faithful as old-fashioned servants,
dependent on their host, the foot; unable to move
on their own, even for a wiggle or squirm.
If their nerves linked up with the brain's pleasure palace,
ah, then they'd move uptown, be adorned
and much in demand. Or if they could take root
we might rise to amazing stalks.

But I guess they're content enough, with little to do
except spread to help us walk, curl so we can
sneak on tiptoe, dance ballet, toe the line, tap
to jazzy rhythms. If they were graceful as fingers or
dropped from the genome in favor of a simple
but elegant hoof, the risk of organic sprawl
would much increase, for it takes a hierarchy
to make a body's uptown and downtown villages.

2. Song of the Piano Rolls

The player-piano inside my head
 unrolls a bittersweet melody
 that makes me dance
 even if I seem to be motionless;
 a fusion of tango & waltz
from a time before I was born
 that makes me crave entry
 to a village of lost colors
 where I'm destined to move
 with such passion & grace
people rush from the fields
just to watch me perform.

After years of craving, one day
 I realized both village & song
 owed their lives
 to the beat and pause
 of the chords in my mind,
itself an interlude
both revealed & enclosed
by the world outside its frame.

Yet I'd keep listening, sometimes hoping
 the sounds that aroused my impossible craving
 would merge to white noise, the village
 fade as well; wish the instruments
 that played my bittersweet dream-song
would shatter once & for all, so I could sing
the same Top 40 as everyone else.

Luckily, the wish never worked.
 For to this day I keep listening, not just
 to that stubborn old song
 but for all the new melodies that wait
 for release from the piano-rolls
inside my head, each its own interplay
of bitter & sweet,
even if nobody else sings along.

3. Song of the Scissors & Clips

I keep my scissor blades sharp, make sure
 the screw that joins them won't loosen,
 for what's the point of one-legged scissors?
 Make sure as well the holes for finger & thumb
 stay wide open as insomniac eyes
 in case I urgently need to cut today from yesterday
 with no rippled edges that might rejoin
 on their own what I've split.
Nearby I also keep a gun
 filled with staples, boxes of clips, pins,
 & a glue-stick, to ensure reconnection
 lest I change my mind, need to rejoin a day
 with the one that came before, a seamless
 fabric of the known with its ritual assurance
 that I need not reinvent myself each morning.

In long-ago Brooklyn I'd listen
 for the scissors-man, his wagon rumbling
 down the street while he belted out
 his high-pitched siren-song, how he could
 sharpen the dullest of blades, not only scissors
 but knives; fix pots & umbrellas, too.

I think he was a tenor, a slightly different aria
 each time he rode by. He could have been singing
 Italian—Hungarian, Chinese, even Yiddish.
 Was there only one scissors-man or a series, each
 different, yet each seamlessly joined with the man
 of the previous day?

But I recall no singing healers of clips or pins.
 As if they never get dull, only the worn-out days
 they connected. Though of course the clips
 could come loose, pins slip free from seams,
 go their own way & scatter all they held,
 despite risk of rolling into a crack,
 being crushed flat
 by the scissor-man's wheels.

4. Song of the Hidden

Easily I can sing in praise
of the perfect five-pointed star
concealed in the belly of an apple;
the surprise of indigo berries
inside the layers of a leaf-pod;
the hidden curve of a swan's neck
dipped into a river, the swan
rising to flaunt once more
its arched elegance;
a tongue's ability
to curl politely in a mouth
until called upon; how an orchid
hides its reservoir of nectar
down a deep shaft, demanding
acrobatic skills
of the bees and moths
who dare to probe, risk their lives.

Sometimes the one who hides
deserves at least as much praise
as the hidden: so I sing to the
Polish women who secretly
sheltered Jews, to the mother
who wraps her only shawl
around her infant, her own body
warmed by shrouds of snow;
those who hide paintings and books
from the fires of the crazed.

But no praise
for the back of the moon,
backs of our eyes, beat and flow
of our intricate cellular dance:
the hidden that's never revealed.

5. Song of the Tacks & Pins

Bless the thumbtacks.
With the yellow ones, thwarted suns,
I form a lemon grove on my cork-board,
so the lemons can encircle
my scattered papers—bills, calling cards,
scrawled notes—keep them from detaching.
I add a few lime-green tacks
that in another life might have been
traffic lights and a single red fruit
which could be a migrant apple
from one of many other
metallic orchards that bloom
inside my house
despite lack of light and rain:

The thickets of nails that hold in place
the wood of old chairs, black ones
clustered like berries; a copse of pins
that keeps the curtains intact
their small circles resembling
the first swellings of grapes;
whole meadows of snaps, hooks and eyes
that flourish inside my closets;
rows of staples and clips
creating long fences to keep out
stray papers from the sheaves
they attach.

Bless the thumbtacks
and all things that pierce in order to join
even when my bare foot steps on one
that has fallen, forcing me to rise
higher than all the landscapes above,
descending only to gather
enough tacks and pins
to make an orchard of stars.

6. Song of the Microbes

We are ancient.
We are gorgeous.
We are everywhere.
In the salt-encrusted Dead Sea water,
the rumens of cows, our spores
embedded in brine, ice, leather, dust.

We are blue, green, and purple,
spiral, oval, twisted, chained.
We can glide, we can hunt,
We can swarm, dance, and kill.
And O how we can replicate.

You would scrub us and scorch us,
alert the White Guard to engulf us,
drug us to a transient death,
your invisible servants,
always ready to prepare just for you
a feast of wine and bread, golden cheddar.

We wait for you in bureau drawers.
We wait for you in books.
We wait inside your breath
and body, by far more numerous,
more intimate than stars.

We are ancient.
We are gorgeous.
Mostly we are harmless.
So consider us family—
Do we not share a common ancestor?

Come, bid us welcome
to your most sacred places.
Our demands are few
and who knows? We might sustain
a bit of you inside our spores
long after you're forgotten.

7. Song of the Contours

Where my head's now propped on a pillow,
 eyes focused on the Sunday *Times,*
 at one time a burl swelled from willow bark.
 Before that a tangle of branches and leaves.
 Back further, air filled its contours,
slashed at times by falling snow or rain;
 yet more remote, a space
 where medleys of newly formed particles
 swarmed through a blackness recently cooled,
 small gaps in its once compact matter.
Earlier still? A multitude of guesses,
 perhaps a hole in an energy field, perhaps
 a point, centers without a circumference...
 Where my spine curves to fit
 the sofa's upholstered rills
birds flew from branch to branch
 in search of berries; a rush of bees
 detecting nectar; across the twigs
 cautious processions of squirrels.
 Where my feet
dangle across the edge, a small tornado, its whirl
 downing trees, birds scurrying to bushes,
 many caught in a bog that seethes just below
 my sun-polished floor's wooden planks.
 Beneath the long-disappeared bushes and bog
there still might be reindeer bones,
 carcasses of polar bears from when ice
 encased everything, pack-ice and drift-ice,
 sea-ice with blue and green bands,
 colors that at times make me crave

the chance to see them first hand, hear any words
 that might have imprinted the space between my walls,
 any music drifted through cracks; learn who, if anyone,
 died inside my borders.
 But knowing the likely letdown, quickly I shift
 from *then* to *next*.

Centuries from now, the space my sprawled body frames
 as I read the Sunday *Times*
 will fill with laser-blocks, a tower
 that takes in whole cities
 after the asteroid scars have healed.
Such a distant possibility I can tolerate with ease.
 More disturbing the thought
 that prior to such catastrophic change
 another person, shaped much like me,
 will fill my contours, never wondering
about the trees and birds, the particles
 that preceded her, let alone about me...
 I could leave her a souvenir, small token
 of my presence; breath that has passed
 through my body, invisible shreds of skin, a hair—

Better to bequeath
 a capacity to wonder
 about what filled her space
 long before she was born,
 the curse and the gift of history;
and the capacity to speculate
 about what's to come—
 For I fear she might be so content
 even could I offer such turns of mind,
 she'd delete them at once
so they won't interfere
 with the numbing blare of colors and sound
 that have replaced my walls, my ceilings,
 the folds of space that now hold
 my Sunday *Times*.

DEAD ON SURVIVAL:
Schrodinger's Cat Rebels

• Why not a dog, Dr. Schrodinger—or an armadillo? Either would work to prove your paradox.

• Look. I'm either dead, alive, or both at the same time.

• Which makes me no different from anyone who's ever lived or died, including you, Herr Dr. Schrodinger.

• So in the name of all the world's cats I demand a halt to the practice of locking a cat in a windowless box—in the name of what you call science.

• A box rigged with radioactive beams and a dish of cream; odds no better than 50–50 whether the moment that cat dips its tongue in the dish it rolls over dead from one lethal droplet.

• Or licks its whiskers and laps up all that cream, purrs in readiness for another round of your quantum roulette.

• Looks can kill, agreed?

• But the joke's on you, Dr. Schrodinger. Creatures of the night, we cats have luminiferous eyes, retinas packed with more rods than any habitué of Vienna's all-night cafes or boudoirs of the Volksgarten's night-ladies.

• The lamps in our eyes so laser-sharp they can cut through the stoutest walls, aim right at you—or whoever plans to confound your paradoxical caper by lifting that box's lid:

• Dead on survival, dead at first glance.

THE RITUAL

To lie in the hot black mud
an attendant with embroidered hands
has slathered over my body
prior to the swaddling and the sealing,
the painless expunging of my darkest sins,
the poisons, maggots, live coals—

What better indulgence than a *Schlammpackung:*
a mudbath of mudbaths, so massive it might
well have made the dinosaurs extinct,
burnished the heart of Satan himself
had he bathed between accumulations
of all that filthy lucre.

"Just call if you need me." She locks
the cubicle door, leaves with a click
of her smile as the mud begins
to suction my sins
until I'm too pure to remember
except in name
the jealousies and hurts, both felt
and inflicted; the coffers of pills,
the lethargy, boredom, self-abuse,
other such afflictions of the spirit.

Soon I'm a gutted sack, a mummified cat,
ducts and vessels drained;
a church without penitents,
Europe without its gypsies and Jews.
Enough in any language,
But when I summon the attendant
my mouth clamps shut.
She's forgotten me, the bitch,
left me to lie in this cubicle,
the mud congealed and cold,
parched as the stalk of my tongue.

How could I have missed the disguise
of one of death's many attendants,
scrubbed, stiff as linen
stretched on a wooden embroidery hoop,
her ritual script set with digital precision.

—Budapest, 2002

MEMORY'S HANDS

In my first memory
I'm trying to grasp
the ribbons of sunlight
that managed to slip through
the blinds' narrow slats
but my hands were too small
to hold the light
long enough to remember
how it tasted or felt.

My last memory, I suspect,
will be similar but reversed,
as wide bands of darkness
try to grasp my hands
and tug me through a narrow slat
into a place with no windows or walls
and that my hands will resist
until the darkness expands
wraps itself around me
until there's nothing more to remember.

TIGER LILIES & HORSE CHESTNUTS

Had I been alive when flowers
could interchange with hands
I'd have attached a tiger-lily
to one wrist, branch
of a horse-chestnut tree to the other.

My six tapered lily-fingers
would enclose whatever I wished:
a plum, an apricot, a stone marked
with veinwork that matched their petals.
That flower-hand could also spread open,
the hand of a child performing
a Balinese finger-dance, while my
horse-chestnut hand's fan-shaped leaves
would cool me and intercept the dust.

But if so mindlessly hybrid
how could I now recall
the lilies destined to bloom
by that house in Mount Fern,
and the horse-chestnut tree, cut down
with the house: its trunk once bound
by a bench my grandfather built from logs
just for me to sit reading and singing,
gazing out at the tiger-lilies,
up at the horse-chestnut leaves.

REMEMBERING DISTANT LIGHTS:
Three Scenarios & a Coda

1. —I'll never forget the moment I first saw the Irish coast, its distant lights discernible at last from the Queen Mary's deck.

—"We're in Europe!" I cry out to my young husband.

—A woman, her face now one of my memory's many lacunae, points to a cluster of lights and says, "That must be Bournemouth." The place where she would soon begin married life with her uniformed British mate. Who promptly taunts his wife, "No, no. Can't you tell that's not England? It's just Ireland." He turns towards me: "And it's surely not Europe, m'am."

—No camera preserves that moment of distant lights. Memory itself is the photographer. Weather, the surf, the paint on the deck of the Queen Mary: all pared away by the sharply-edged lens of my inner eye, only the view of the lights becoming a memory-print. Impersonal. Indifferent. Unlike the original moment, so charged with delight.

—This much I know: the more distant the moment, the more I can later contour and color its memory-print, fill in what's missing.

—A couple of years ago, I would stain the memory of those Irish lights with dark lamentations: nostalgia at its worst, replete with cravings to be young and naive again.

—Today I cover everything with a blue-violet poignancy. Who was that young couple, did they really settle in Bournemouth, were they happy, are they still alive, are we? All I know is that the poignancy supplants the joy of first seeing those lights.

—Yet since I am free to retouch my prints as I might wish, sometimes I tinge the moment a comical orange, insisting, the hell what anyone says, that Ireland's indeed part of that Europe I've since chosen to visit so many times. (That's not to say I won't once again stain the moment black some time in the future.)

2. —**Markedly different, the memory of distant lights in the mind of a man named Franz Lowen.** In 1938 he was one of the few to survive the doomed ship St. Louis, filled with late refugees from Berlin and Vienna.

—He recalls seeing the lights from hotels that lined the Miami shoreline, the ship having docked so close to America certainly permission to land and release of the more than 900 passengers was imminent. The possibility that last minute diplomatic schemes on the part of America and Cuba would culminate in their forced return to Europe's infernos? More remote than the silhouetted figures he could see beckoning from behind the hotels' bright windows.

—Of course, Franz's memory of those lights on the Miami shoreline is scored with fractures and voids like any other memory-print, its absences open for shaping, coloring, filling.

—Except he can only color the empty spaces with rage.

—No matter how often the moment returns in a dream, in the midst of a festive dinner at a candle-lit restaurant by the sea, in yet another interview while there's still time to record...

3. **—In this one my mother is crying.** She lies on a maroon sofa, plaiting her long thin fingers, then turning them loose so she can wring them in a strange little dance. Apart from her occasional sighs, I recall no sounds. Nor do I recall any reason for her melancholy that particular day. I only want her to stop. Stop before friends arrive, stop before she drives me crazy and I, too, began to invent strange little finger dances. But she refuses to stop even when it gets dark; orders me not to turn on any lights. And to make sure the maroon drapes are tightly drawn.

—After a while I can see the lighting of lamps in our apartment building's other windows; kitchen lights, hallway lights, bathroom lights. Whole shelves of lights. But because I can only see them through the tightly drawn maroon drapes, the lights appear dim and distant though some are only a few feet away.

—Then my mother complains that she cannot see. Has she gone blind? I reach for a lamp switch but even in her self-proclaimed blindness, my mother insists the room must be absent of all light. Finally she sleeps.

—There were other such moments. But now I know a bit more about light and dark; realize that sometimes the healing of a memory depends on the presence of something originally absent, a presence that might appear only years later. So when the memory returns, I light a small candle. Its flame creates a powdery yet translucent film across the living room, its objects beginning to diffuse but not disappear. At the same time my mother's face shines like the face of a gold statue I once saw in a Japanese shrine.

CODA : —Even if moments could think, none could predict which would be preserved as a memory, which not. Indeed, the vast majority will sink below the range of the inner lens, forever an absence with no presences. What happens to them? Might as well speculate about what happens to the billions of sperm that never fertilize an egg in any one particular act of conception.

—Enough to say they lose all potency; fall asleep, as it were, a few lights blinking, then becoming more dim than the distant lights of the Irish coast, the Miami shoreline. As well the lights of Bournemouth, England, or wherever that woman and her British mate might now live. If indeed they still live. As well the extinguished lights of the houses in which my own marriage lived until it died. As well the lamps I've yet to turn on in my later years....

RAIN-HAIR

Pins tumble loose
from the clouds' stretched seams
and the rain at last lets down its hair

like an old woman
grateful for darkness, promise of sleep,
long gray strands of rain

falling swiftly, sometimes
enbraiding each other
before joining strands already merged

with mud and puddles on the pavement.
Slowing down, the rain becomes
thick strands of a mop

and begins to wash itself away
as if at the end of the day
all the cut hair

on a barber shop floor
swept itself up, the linoleum a bald pate
ready to receive the hair
of tomorrow's first customers.

RED LACQUER BOWLS

Today in the heart of the city
I saw ten red lacquer bowls
equally arranged
around an old tire
with pebble-filled spokes,
at the bottom of each empty bowl
an identical gold-rimmed
black hexagon.

In a few days each petal
will begin to flare and wilt
detach from its stalk
to become one of many
scattered red tongues,
some clinging to the tire-grooves,
others sunk in the late April mud;
a few punched with small holes
from soles of passing shoes;
crushed to slippery strings
that swarm like worms—

All giving way
to the next round,
leaving only their bulbs
to begin once again
in the dark privacy of their clay
the long slow shaping
to red lacquer bowls.